ON THE FRONT LINES OF

PENNSYLVANIA POLITICS

D0326056

ON THE FRONT LINES OF

PENNSYLVANIA POLITICS

TWENTY-FIVE YEARS
OF KEYSTONE
REPORTING

JOHN M. BAER

THE
History
PRESS

Published by The History Press
Charleston, SC 29403
www.historypress.net

Copyright © 2012 by John M. Baer
All rights reserved

First published 2012

Manufactured in the United States

ISBN 978.1.60949.715.6

Library of Congress CIP data applied for.

CONTENTS

ACKNOWLEDGEMENTS AND DEDICATION

Thanks to friends and chapter readers Walter Cohen, Peter Durantine, Bob Gentzel, Bill Green and Don Sarvey; to the only editor I've had in twenty-five years at the *Daily News*, my long-suffering friend, city editor Gar Joseph, whose judgment is invaluable to me; to *Daily News* editor Michael Days; to *Philadelphia Inquirer* and *Daily News* director of photography Michael Mercanti; to Philadelphia Media Network, Interstate General Media, Inc., company image angel Jackie Rose; to the Harrisburg *Patriot-News*; to *Philadelphia Magazine*; and to *Daily News* Pulitzer Prize-winning cartoonist Signe Wilkinson, all of whose help and gracious support made this book possible.

This book is dedicated to my wife, Rosemary; my sons John and James; and every journalist who has experienced the agony and ecstasy of covering Pennsylvania politics.

FOREWORD

I drove from Philadelphia to Harrisburg a while ago to hash out an idea with a bunch of media people. Things were going just fine until I arrived at the address I had been given for the meeting.

When I pulled my car into the small parking lot behind a run-down structure, I could see clots of seedy characters and signs indicating that both abortions and drug rehab took place inside.

I called John Baer and explained my problem.

"How," he asked, "did you wind up at the Capitol building?"

Now, it is many years earlier.

I had been to Harrisburg before, but I had never really been to the political heart of the commonwealth until I toured the city with John.

If the *Philadelphia Daily News* was going to get out of its Philly-centric cave and start paying attention to Pennsylvania's miscreants and decision-makers—often there is overlap—Baer thought the boss needed to experience the political core of the state capital.

It was a little like touring Hollywood with Brad Pitt.

We dropped in wherever Baer pleased. In one office, we found a lobbyist with her long legs up on the desk of one of the leaders of the General Assembly.

Everyone knew Baer. They needled him, of course, usually over something he had just written about them. But they crossed the street to talk to him. Beyond the political bravado, you could feel their genuine respect and perhaps even a little affection.

"Oh, the pols get angry at him," says Gar Joseph, his long-time editor at the *News*. "But they don't stay mad. They know he'll stick the shiv just as deeply into their rivals the next week."

At first meeting, Baer gives off a certain vibe—a little like the 1940s actor John Garfield. Compact, taut and a little dangerous. A man who is capable of somehow getting you to tell him things you didn't particularly plan to say.

That, of course, is only part of the story.

There is no swagger in him. His understanding of how this state works is deep in his DNA and a byproduct of decades of balancing hope, curiosity and his disappointment in the sinners on the Susquehanna.

He is also the best storyteller at any bar.

Beyond working with John, we have shared much brown whiskey together. Still—if he has one—I couldn't neatly describe his political ideology to you.

He wants Pennsylvania to be better governed than it is. "The Land of Low Expectations," as he calls it, is poorer, less well educated, older and more corrupt than it should be. Yet he never stops hoping for sensible results from the goofballs and "tragic Greeks" who always seem to end up in charge.

Take this slice of a Baer column on voter identification, an issue that happens to be hot as I write:

"To be clear, I'm not talking about whether it makes sense for voters to have photo IDs. It does. But the ill-conceived, politically-driven, bureaucratically-bungled effort to make that happen here and now? A total freakin' mess."

Harrisburg has attracted some terrific reporters and columnists. (Besides David Broder, the legendary *Washington Post* political writer, I can't think of a journalist other than Baer who so successfully merged those two very different skills.) But often these people get their ticket punched in Harrisburg and move on.

Baer stays. Partly because he is a true son of central Pennsylvania.

But mostly because he is the finest watchdog in a town that desperately needs one.

—Zack Stalberg was editor of the Philadelphia Daily News *from 1984 to 2005. He is now president of the Committee of Seventy, a Philadelphia-based non-partisan organization that fights for better government.*

INTRODUCTION

This is not, in any strict sense, a history book. It is not an all-inclusive account of the policies and politics of Pennsylvania over the past quarter century. Some people, facts, stories and events of import during that period are given short shrift here or not mentioned at all.

It is instead a mostly chronological, first person recount of the Pennsylvania politics I saw face-to-face; a look at the reasons the commonwealth is a goldmine for any political journalist.

I am fortunate to be one in my home state.

I was born in Harrisburg, capital city of the commonwealth, a place whose politics and government I knew nothing about at the time, since, well, I was just born.

But that would change.

I would come to see the ins and outs, the ups and downs, the folly and fun of a very strange and always amusing political system (and the characters it produces) from a post in the Capitol newsroom.

Let me note, because it's symbolic and instructive, that the Capitol newsroom is located on the "E" floor of the main Capitol building, which is actually the second floor in any part of the real world but, I suspect, "E" in the Capitol in order to confuse visitors and whistleblowers.

Also, room numbers on "E" floor are all in the 500s, no doubt to prank anybody looking for a 500-numbered room on the fifth floor.

Your government at your service.

(To be completely fair, the "E" stands for entresol, a word literally meaning between-floor, and a roundabout way of saying mezzanine. No doubt some architect back when thought it quaint. I think its use in this particular Capitol underscores the fact that you, dear citizen, have entered a place and a culture that's arcane and difficult to navigate.)

My earliest exposure to the grandeur of the Capitol, a national landmark, and its entresol, came as a young boy. My late father, John H. Baer, was a long-time Capitol correspondent for the Harrisburg *Patriot-News.* I often went with him to the newsroom after Sunday mass at St. Patrick's Cathedral a half-block away.

My father had a thing for Capitols. From the time of my memory, our summer vacations consisted of driving all over America. By my early teens, there were photographs of me standing in front of each of the forty-eight Capitols in the continental United States. Quirky, no? As you might imagine, my interest in this annual outing waned as I aged. And the photos, stored in our basement, were lost in a 1972 flood; in retrospect, a shame.

We lived in Harrisburg's Allison Hill section, an easy walk from the Capitol complex, in a three-story brick row house. This was on Evergreen Street, which had chestnut trees, something I always found odd since the closest cross-street was Chestnut Street, which I'm pretty sure had evergreen trees.

I think the street/tree thing was due to the fact we were located too close to the Capitol and, therefore, impacted by its aura of oddness.

At any rate, Allison Hill today is what law enforcement types refer to as a "high-crime area" and what most people call a "war zone." Back then it was a quiet neighborhood with a corner store with a soda fountain, a farmers' market, a firehouse, a good restaurant (The Hill Café) and lots of alleys to play in.

But I digress.

The Capitol newsroom houses the oldest legislative correspondents' association in America, officially formed in 1895. Photos of members dating back that far hang on newsroom walls. When I visited there as a ten-year-old or younger, I would mostly filch Cokes from the backroom refrigerator (I think the same one's still there) and play with the phones, the kind you don't see any more: mouthpiece on a standing stem with a rotary dial at the base and a large earmuff-type earpiece.

When I tell people that as a child I played on the phones in the Capitol newsroom, I usually get a response along the lines of, "It's nice to know some things never change."

But they do, my friends. They do.

In my father's time, relationships between and among political journalists and politicians were different than in my time. In the holiday season back then, baskets of booze showed up in the newsroom and boxed bottles of high-end bourbon, my father's preference, appeared on our house stoop. This was courtesy of bigwigs at the state Liquor Control Board (yes, in Pennsylvania we have a "board" to control liquor) or others holding, seeking or staffing public office.

There were social gatherings as well. I recall pool parties at what is now the lieutenant governor's residence and was then the governor's summer residence at Fort Indiantown Gap, a National Guard training center twenty-four miles from Harrisburg, where the governor hosted reporters and their families.

Those days are gone. So let's fast-forward.

I started in journalism as a general assignment reporter for the Harrisburg *Patriot-News* in June 1972. This was the same month as the worst natural disaster (so far) in Pennsylvania history, Tropical Storm Agnes, and the same month as the Watergate break-in.

Agnes killed forty-eight Pennsylvanians and left an estimated $2 billion in damage. Watergate killed a national administration and altered journalism, politics and presidential history. Both events provided endless stories and follow-ups.

It was a great time to be a new reporter.

And what lay ahead was more fun than any one journalist should dare to expect. Covering politics in Pennsylvania is like going to the circus every day. I've done my share of mainstream stuff—national political conventions, impeachment proceedings against President Clinton, even witnessed an execution—but it's the ongoing parade of missteps, misdeeds and characters that Pennsylvania politics provides that makes the state a joy for journalists.

What follows is an effort to share a journey, to offer highlights from twenty-five years of front-line coverage of politics and government in a state that offers reporters, editors, broadcasters, commentators, columnists, editorial writers, cartoonists and anyone who cares to pay close attention endless entertainment.

CHAPTER 1

THE KEYSTONE STATE
I KNOW AND LOVE

L et's focus on the Keystone State by first stepping back and taking a wide-angle view of its history and politics.

If you look at Pennsylvania in historic terms from the broadest possible perspective, what you see is an odd, ironic disconnect. This was the place, after all, dubbed the "Cradle of Democracy," the keystone of the colonies, the birthplace of the nation, home to the Declaration of Independence and the Constitution.

What better geographic spot to evolve as a model for good government, good politics and sound civic leadership?

Yet if you look at the state in terms of influence in national politics and national leadership since those early glory days, we look like a place of small consequence.

Think about this: Pennsylvania has had one president—ever. Virginia has had eight, Ohio seven, New York six, Massachusetts four, Texas four, Tennessee three and California three. We've had one, James Buchanan (1857–1861), perhaps best known for regularly showing up on almost every list of worst presidents; and, I might add, rightly so.

Buchanan was a federal flop and a bit of a fop, regarded as governmentally dull and morally obtuse. Not surprisingly, he had been a member of the Pennsylvania Legislature.

He was a rich bachelor, an epicure and an impeccable dresser. He was a Northerner who championed the South on the eve of the Civil War, and as Southern states began leaving the union, he advocated the protection of slavery.

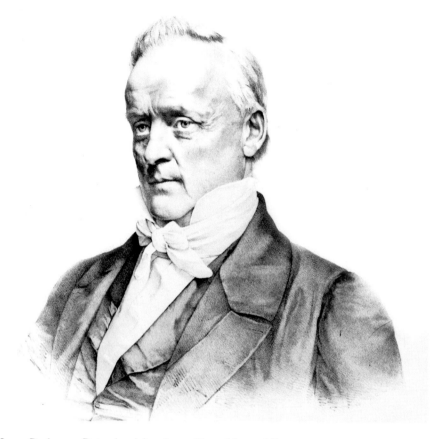

James Buchanan, Pennsylvania's only president. *Library of Congress.*

Did I mention he'd been a member of the Pennsylvania Legislature?

Before he was president, he worked in foreign service, including in Russia. President Andrew Jackson, who appointed Buchanan Russian ambassador, said, "It was as far as I could send him out of my sight. I would have sent him to the North Pole if we had kept a minister there."

Oh, yeah, then there's that thing about Buchanan being gay or bisexual and living with William Rufus King, the vice president from the preceding administration, who was referred to as "Mrs. B." or "Aunt Fancy" or Buchanan's "wife."

And you thought the sex stuff started with Bill Clinton.

When Buchanan left office, the union was coming asunder. He said, "I am the last president of the United States." He probably was edited and really said, "I am the last president of the United States from Pennsylvania."

I mean, it's conceivable there's some curse, perhaps conveyed by the original inhabitants of Penn's Woods—the Delawares, the Susquehannocks, the Shawnees—who maybe used tribal incantations to assure that the spawn of the white men who took their land be politically neutered and trapped within its borders forevermore so that none of their descendants (okay, maybe one) would ever rule over the nation.

Just a theory.

There are, of course, other theories as to why we've only had one president: the state's politics are parochial and rarely reach for big ideas and therefore never produce politicians of national stature; our pols are more interested in patronage jobs than national politics; the real power in Pennsylvania is the money and special interests behind our pols and is more focused on getting contracts than creating national candidates.

There's some truth to all of that.

And it's not that Pennsylvanians haven't run for president. In fact, the curse theory gets, I think, extra credence when you look at those who've served in office in the state and also sought the White House.

In 1964, Governor William W. Scranton took an eleventh-hour run at stopping Barry Goldwater's nomination at the Republican convention in San Francisco. It was too little, too late.

In 1976, Democratic governor Milton Shapp ran in the Florida primary and finished behind "no preference." Political humorist Mark Russell said voters in the Sunshine State thought Milton Shapp was "a bond issue."

In 1992, Governor Robert Casey got ten delegate votes at the Democratic National Convention in New York City. That was just 2,135 votes shy of the total needed to capture the crown.

In 1995, Senator Arlen Specter announced his run for president. He was booed in Iowa, finished behind "don't know" in opinion polls and pulled out of the race before the 1996 election year started.

In 2012, former senator Rick Santorum won the Iowa caucuses (by one-tenth of one percent) and later won several Midwest and Southern states, but said some stupid things, ran out of money and left the race before the Pennsylvania primary.

I should probably mention that none of these aspirants was born in Pennsylvania. Scranton was born in Connecticut, Shapp in Ohio, Casey in New York, Specter in Kansas and Santorum in Virginia.

Now maybe you're thinking, wait, what about Abe Lincoln and Gettysburg? Nope. Abe *spoke* at Gettysburg but was born in Kentucky, elected to Congress from Illinois. If you're thinking Dwight Eisenhower and

Gettysburg, it's because Ike had a farm there but was born in Texas, grew up in Kansas and *retired* to Gettysburg.

And while the "final four" for the GOP presidential nomination in 2012 included three candidates with strong Pennsylvania ties—Santorum, Ron Paul and Newt Gingrich—I'd point out that while Paul was born in Pittsburgh (and graduated from Gettysburg College) and Newt was born in Harrisburg, both have about the same chance of ever living in the White House as Scranton, Shapp, Casey, Specter or Santorum (assuming, as I do, there's no second act for Rick in 2016 or beyond; unless, of course, the entire nation goes whole-hog hard right).

Again, it's like our pols live under a curse. The state with the nation's first capital, first mint, first zoo, first art institute, first stock exchange, first radio broadcast, first baseball stadium *and first American flag* comes up consistently short on the national stage, and very far from first.

But let me say this: whether Pennsylvania pols have success or failure, they remain, in my view, tons of fun to write about.

It was Shapp's brief '76 run, for example, that allowed me, while a reporter at the Harrisburg *Patriot-News*, to write my first long political piece, "Goodbye, Milton," which appeared in the June 1976 issue of *Philadelphia Magazine*.

I wrote that when he launched his campaign there was actually a scenario for Shapp to make a national splash. He was a social liberal and fiscal conservative, a millionaire cable-TV guy and two-term governor (the first allowed under state law) from a large, delegate- and Electoral College vote-rich state that happened to be front and center in celebrating the nation's bicentennial year.

Remember? 1776–1976?

Pennsylvania got lots of attention that year. Also, in what started out as a crowded Democratic field, Shapp was set to host that year's National Governors' Association conference just prior to the Democratic National Convention in New York. More attention! Then at the convention, he would command the third largest delegation on the floor and so, in case of a brokered convention, be well-positioned to shape the national ticket and maybe even grab its bottom half.

He was, I wrote, a dark horse player who could become a player on the national stage.

But then he showed up. And voters met him. He was short, stooped-shouldered, wore ill-fitting suits, spoke in halting, annoying phrases, had a bad haircut and looked more like the owner of a men's clothing store that was going out of business than a man ready and able to run the country.

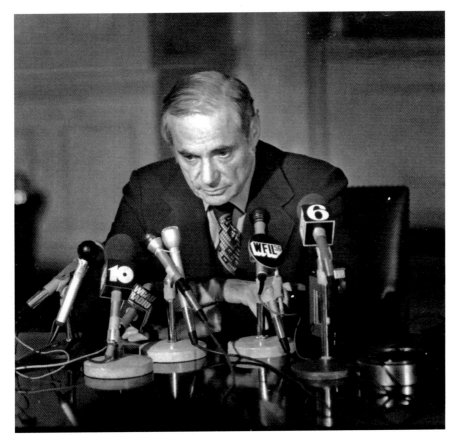

Governor Milton Shapp. His 1976 run for president was short-lived. Philadelphia Inquirer.

Some called him "Uncle Miltie." The *New York Times*, possibly on purpose, misspelled his name more than once ("Marvin Sharp" was my personal favorite). So the dark horse became a donkey in almost record time. Here's an excerpt summing up his grim campaign facts.

It took 170 days and $850,000. It won 3% of the vote in Massachusetts, 2% in Florida. The total effort produced one convention delegate...On March 2nd, as a Northern liberal governor running in a Northern liberal state he somehow managed a ninth-place finish behind right-to-lifer Ellen McCormack and called it a beginning, not the end. On March 9th, as the only Jewish candidate in the very Jewish state of Florida, he was outpolled by `No Preference.'On March 12th, the man dubbed the Rodney

Dangerfield of Campaign '76 stood at a podium in Harrisburg and gave himself the hook.
—Philadelphia Magazine, *June 1976*

Shapp, of course, was neither the first nor last Pennsylvania pol to humiliate himself on the national stage. But we are still focused here on the larger picture of our state's political structure and why and how that helps contribute to its overall political culture.

For example, it is often and easily forgotten that the Quaker province that became the commonwealth of Pennsylvania was founded on principles of protest, individual freedoms, tolerance and independence that later were forged in a revolution that sought better representation of its citizens' wishes and better care of its citizens' well-being.

And yet, despite this glorious history and high-minded beginning, we have become a state of status quo, of cumbersome government and very suspect representation.

Not that there isn't a lot of it.

We have 67 counties, 57 cities, 960 boroughs, 1,547 townships and one town, Bloomsburg, (for a total of 2,565 municipalities, all with various local boards and commissions). We also have 500 school districts and the largest full-time legislature in America (253 members), supported by a staff of more than 2,000.

All this overlapping, duplicative government is costly and inefficient and seems to survive solely on the strength of its own being, layer upon layer eating tax dollars year after year and, coincidently, making a case that having big government isn't the way to have good government.

For with all this governance, perhaps because of it, we are a state with a well-deserved national reputation for corruption.

When the *New York Times*, in 2008, compiled state-by-state listings of convicted public officials during the period 1998 through 2007, Pennsylvania ranked fourth with 555. We finished behind three larger states: Texas, New York and Florida.

But I figure since then we've caught up, gone ahead or certainly will soon.

After all, public corruption is one of our ongoing traditions. In recent years, Pennsylvania top politicians investigated, charged, convicted, jailed or pleading guilty to various public offenses include former Democratic Senate appropriations committee chairman Vincent Fumo; former GOP Senate majority leader Joe Loeper; former GOP House Speaker John Perzel; former Democratic House Whip Mike Veon; former Democratic House Speaker Bill DeWeese; former Republican Senate Whip Jane Orie and her sister, former Republican state Supreme Court justice Joan Orie Melvin; former

House Republican Whip Brett Feese; and, earlier, former Republican state Supreme Court justice Rolf Larsen.

And this is not the full list.

The state's custom of corruption endures, as does the custom of being non-progressive, anti-reform and holding one of the nation's worst records in terms of women in elective office.

WHY WE ARE THE WAY WE ARE

At this point, if you live in Pennsylvania, you're probably nodding in agreement but wondering why we are the way we are. Good question. I think there are three main reasons: apathy, partisanship and geography.

Let's look at apathy first.

With all the government in place in Pennsylvania for so long, you might think it would be backed by an active, aggressive electorate. Not so. Incumbent state lawmakers routinely post reelection rates topping 90 percent. Most usually run without opponents, many without opponents in either primary or general elections. Think 90 percent of our citizens believe our legislature does a consistently good job?

Yeah, me neither.

We have around 9 million residents of voting age. In the 2008 presidential election (an exciting, competitive race), 5.9 million voted. That's about 64 percent, which is good. Presidential years always bring out higher numbers than non-presidential years. But in 2008, twenty-five other states that were NOT the "Cradle of the Democracy" did better.

(Minnesota had the highest turnout percentage at 77 percent; Arkansas had the lowest at 52 percent).

And in the 2010 governor's race, an open-seat race between Republican Tom Corbett and Democrat Dan Onorato that was also an important congressional mid-term election, statewide turnout was 41 percent.

Thirty-two states did better.

The excuse most often offered for not voting is, well, choices are limited because political parties pick the candidates, and by the time the General Election rolls around, we're sick of the picks.

But here's the thing. In an open-seat race for governor in 1994, both party primaries (ultimately won by Democrat Mark Singel and Republican Tom Ridge) were hotly contested with a real variety of candidates.

There were twelve choices for governor and ten for lieutenant governor.

By the way, another ass-backwards thing we do is vote separately in primaries for governor and lieutenant governor thereby setting us up for handing the state over to two people who don't get along or agree on policy or…no, wait, what I really want to say is, by the way, the office of lieutenant governor is a useless, redundant office that five other states have the good sense not to waste tax dollars on.

(I should know, I worked in the office of the lieutenant governor; more on that later).

The point is that in 1994 the mix of those running offered voters a real smorgasbord. Candidates were Jewish, African American, conservative, liberal, maverick, newcomer, veteran, traditionalist and one or two just plain nuts. In other words, genuine options. Turnout was 23 percent.

Now there are those who argue that given the general knowledge level of the electorate at large, maybe not everyone who can vote should vote. The great American journalist H.L. Mencken once said, "Giving every man the vote has no more made men wise and free than religion has made them good."

Still, I tend to believe that the larger the participation there is in democracy, the truer the democracy tends to be; and, at a minimum, broader participation should cut down on post-election whining because, you know, y'all are the ones who put him or (less likely) her in office.

I'd also note that, no surprise, Pennsylvania is among states that make voting more difficult than it needs to be by sticking to the old rules of voting only on Tuesdays and only in person unless you take the time and make the effort to secure and use an absentee ballot by saying why you won't be able to show up.

Many states allow no-excuse absentee voting and/or mail-drop voting and voting over several days or weeks; in other words, many states make it easy, and we don't. Only twelve other states are as rigid about voting times and places.

The same applies to third-party candidates.

In Pennsylvania, they face a much tougher challenge to get on the ballot than in other states because our state requires five to ten times the number of election petition signatures for anyone running for any office that is not running as a Republican or a Democratic.

Harder to vote, limited choices: the Pennsylvania way.

What about partisanship?

What are its contributions to "the way we are?"

First, it feeds off the apathy our system encourages. We are among the least progressive states in terms of unlocking partisan control, which again, is ironic given our heritage.

We are among only a handful of states with no limits on campaign contributions from individuals, political parties or political action committees in state races.

Only ten other states, not one in the northeast, are as lax. As a result, we are near the top nationally in average campaign dollars raised by winners of legislative seats, in some cases ranking ahead of larger states with smaller legislatures.

Also, we are one of only six states that still elect statewide judges. The other five are Texas, Illinois, Alabama, Louisiana and West Virginia—again, not one in the northeast.

And since voter turnout in judicial elections is even lower than in legislative elections, we ensure that our judicial campaigns are decided by high levels of special-interest influence. Special interests have more to do with electing our judges than our voters do.

Who do you think contributes to judicial races?

Lawyers and law firms that practice or will practice before the judges they pay to elect. Think of an average citizen standing before a court in a personal case overseen by a judge who was backed financially by an opposing lawyer. Fair? Now picture how this same principle creates a system that *by its very nature* taints judicial decisions on major statewide issues such as gambling, school vouchers, tax reform and questions regarding the constitutionality, for example, of gerrymandered legislative redistricting.

Automatically suspect, no?

This is just part of the reason all Pennsylvanians can question whether what gets done is done in the larger interests of the commonwealth or in the narrower interests of incumbents.

Now, let's talk geography.

The state has seven media markets: Philadelphia; Scranton/Wilkes-Barre; Allentown/Bethlehem/Easton; Harrisburg/Lancaster/York; Altoona/Johnston; Pittsburgh; and Erie.

These markets are very different and serve various cultural bases.

When campaign consultants place TV ads for maximum impact, they buy air time before, during and immediately after the most-watched television shows in each media market. That means, for example, lots of political ads around local newscasts in Philadelphia, and lots of political ads around "Wheel of Fortune" in Altoona.

No offense intended to Altoonians.

The state is like the nation: two major markets on either end, a vast rural area in between. The national Democratic political consultant James Carville is often quoted as saying everything between Philadelphia and Pittsburgh is "Alabama without black people."

It's my recollection he actually said everything between Paoli and Squirrel Hill, but the quote was altered to be more generally understood.

Either way, you get the idea. It's a big state that seems more like multiple states than one. As a result, there are very few statewide focal points, very little emphasis on issues that apply to residents in all markets. And the geography of the state and the difference among its regions encourages a parochialism that is reflected in the action (and more often inaction) of the legislature.

For example, property taxes and roads are most often the top concerns of Western Pennsylvania and do not mirror the top concerns of Eastern Pennsylvania, which generally center on education, housing and sprawl issues, as well as urban crime.

When pollsters such as Princeton Survey Research do statewide questions on basic infrastructure needs, they find Philadelphians say the greatest need is for affordable housing for working families, suburban easterners say the greatest need is easing traffic congestion and southwest residents say the greatest need is highway and bridge repair.

The upshot of this?

Incumbents remain incumbents by addressing, if even only with lip service, the local and regional needs of their constituents while the larger, all-encompassing issues such as state tax policy or optimum delivery of human services historically get shorted.

When the Pew Center on the States did a massive study on trends in 2009, its findings for the mid-Atlantic states (Pennsylvania, New York, Delaware, New Jersey and Maryland) suggest the downside of our apathy, partisanship and geography.

Pennsylvania was dead last in "economic well-being" (defined by per capita income); dead last in a category called "new work" (defined as a state's readiness to place employees in jobs in the new economy); dead last in the percentage of population with college degrees; dead last in the percentage of population with graduate degrees; and first by a country mile—and among national leaders—in losing single, college-educated people aged twenty-five to thirty-nine.

Remember, this was a study of trends, things developing over time, things that take time to change, things that have unfolded while we were busy being "the way we are."

And, look, there's no doubt that part of our national culture, part of our human nature is to *not* address emerging problems until or unless they turn into crises.

How else can one explain the plight of the U.S. Postal Service or, sadly, the newspaper industry? I mean, who couldn't see either of those things coming?

But you might expect a state with all the government Pennsylvania supports and pays for, with all the politicians Pennsylvania elects and keeps reelecting, with all the heritage of government for and by the people, that sometime, even once in a while, there'd be some accountability.

AN ASIDE: A REPRESENTATIVE STORY

One area our state pols never fail to perform in is taking care of themselves.

A good example was the opening, without fanfare, of the East Wing of the state capitol in 1987. After eighty-two years of housing themselves in the Main Capitol Building, which somehow served multiple generations of politicians well, lawmakers felt what the state really needed was a new capitol wing.

A section of the $124 million 1987 Capitol addition. *Mark Ludak*/Philadelphia Daily News.

So up went a $124 million, two-story, one-million-square-foot capitol addition right on the back of the old capitol, right over what used to be a parking lot.

Highlights included glass elevators descending into a specially ventilated, fume-free, two-level underground garage; two floors of hand-laid ceramic tile; glass roofs and offices; a lounge area filled with palm trees and looking very much like a high-end hotel lobby; an indoor fountain; a gym for members and staff; and an outdoor computer-synchronized fountain that can spray water in various colors and patterns. I mean taxpayers deserve the best, right?

Of course, when you have new digs—and 96 of the 253 lawmakers, 8 senators and 88 House members moved in—you need new furniture. In this case, that meant $4 million worth of new solid mahogany desks.

Though planned earlier, the new wing opened during the administration of Republican governor Dick "Do More with Less" Thornburgh.

He and aides always and wisely referred to it as "the legislative addition."

LEAVE 'EM LAUGHIN'

Now, I don't want to depress anyone too early in this effort by noting only what's wrong with the state right from the outset. So before we plow through details of twenty-five years of attempted governance, let me share some of my favorite Pennsylvania political moments.

Here's a short list of examples of Pennsylvania politics and government at its worst (or best, if you're a journalist); and, trust me, there are plenty more of what I call shake-your-head stories later in this text.

Biggest Land Grab Attempted by a Pennsylvania Political Family

The father-and-son team of U.S. Representative E.G. "Bud" Shuster and would-be U.S. Representative Bob Shuster was on the 1996 GOP primary ballot. Father Bud, sixty-four at the time, was a powerful veteran congressman, chairman of the House Transportation Committee, certain to win reelection. Son Bob was a thirty-one-year-old lawyer running in the district adjacent to his dad's, both smack in the middle of the state. The two districts combined included all or some of twenty-six of the state's sixty-seven counties and

covered a land mass equal to one-third of the commonwealth. It was a case of Ponderosa Politics. Except Little Bob lost the primary, and the land grab failed. But, fear not. When Bud Shuster resigned from Congress in 2001, another son, Bill, won a special election to succeed him. Bill's still there. On family land.

Two Terrific One-Liners

As noted, Milton Shapp, the state's first two-term governor, was less than stellar in his run for president. I have to give him props, though, for his under-appreciated wit, which was known by many but seen by few. My favorite Shapp line came at the expense of state representative Stephen Freind, a Republican from Delaware County from 1976 to 1993. Freind was the legislature's foremost anti-abortion lawmaker. Shapp was pro-choice. Freind consistently pushed pro-life measures. Shapp once said to aides in private, "Oh, what a Jesus we have in Freind."

Line two came from Philadelphia municipal court judge Jerry Kosinski when he was a state lawmaker (served in the House from 1983 through 1992). He sponsored a measure allowing members of the legislature to perform nuptials. When a reporter asked him if he had a bill in the mill that would let legislators marry people, Kosinski pulled a flat affect, a deadpan look and quietly intoned, "I do."

Best Example of Pennsylvania's Worst Politicians

Sure, there are many Pennsylvania politicians sent to prison for misuse of their offices and various public crimes, but that's pretty common stuff when compared to Western Pennsylvania's Joe Kolter. He served in the state House from 1969 to 1982 and seemed headed for a long run and coveted seniority in the U.S. House, to which he was elected in 1982. But the veteran Democrat got knocked off the public payroll in the spring primary of 1992 by his own hand, or rather by his own mouth. He was made a *former* congressman after being caught on tape telling his staff he was "a political whore" and asking them to (and this is right out of the movies) find him some wakes in his home district north of Pittsburgh so he could drop in, "shed a little tear and sign my name and take off." As if that wasn't enough, Kolter later pled guilty to conspiracy in a U.S. House stamps-for-cash scandal. He admitted pocketing

$9,300 in cash by turning in officially-purchased stamps for money at the House Post Office. He went to prison. I mention Kolter because while many pols are phonies and many pols are crooks, he was a two-fer.

Best Example of Pennsylvania's Stupidest Gubernatorial Aides

Sometimes those who get close to power get blinded by its light. That must have happened to one John D. Catone when he was a low-level aide to Governor Casey. While serving as something called "deputy special assistant" in 1992, Catone tried to get a monthly salary from a Florida computer security firm on the basis of his access and influence to and with the Casey administration. Almost unbelievably, Catone wrote letters to the company touting his "entrée," while seeking a meal ticket. "Presently, I can open a lot of doors," he wrote. He also told the company he had unrestricted access to his capitol office and unrestricted use of a computer and printer and could make nationwide phone calls any time "at no expense" to the company. "As you can imagine," he wrote, "not many offices in government would allow this." Actually, neither did his. He got caught and busted by the state Ethics Commission and his job-hopping career in Pennsylvania government—he had worked for the House, the Senate and the Turnpike Commission, all bastions of ethically-challenged appointees—came to an end. But, as we will see, greed, avarice and stupidity in Pennsylvania politics did not.

How Pennsylvania (and I) Got From Thornburgh to Casey

In 1978, Richard L. "Dick" Thornburgh, a horned-rim-glasses-wearing former U.S. attorney from Pittsburgh and former assistant attorney general in Washington, won the Republican primary for governor by beating six other candidates, including future U.S. senator Arlen Specter. Thornburgh is one of the steadiest, stablest politicians I've met; Specter one of the most entertaining. For journalists, Thornburgh was a quiet walk on a still spring day; Specter was fireworks on the fourth of July.

But let's not get ahead of ourselves. I'll have plenty about Specter later.

Back in '78, Thornburgh had a tough-on-crime reputation at a time when being tough on crime was really popular in Pennsylvania, which is to say, near the end of Governor Milton Shapp's administration.

Shapp's reign was plagued by scandal: a string of convictions of Shapp pals and political allies, including two cabinet members; his hand-picked turnpike boss and sixty-plus lesser underlings were nabbed for everything from highway contract kickbacks to macing employees for political contributions.

Shapp, his folks and many Democrats maintained that Thornburgh used his prosecutorial office for his own advancement and leaked stories to the press to smooth a political path for himself. (This will ring a bell to those who followed Republican governor Tom Corbett's path to election in 2010; Democratic charges in the mid-seventies were repeated because, you know, any politician charged with a crime says the charge is politically motivated.)

I wrote an article about Thornburgh for *Pittsburgh Magazine* before he was an announced candidate. When I asked him about Shapp's allegations, he told me that on "deep background" his office would help reporters avoid inaccurate stories from appearing in print and that it would confirm the existence of "live" investigations, but nothing more.

Thornburgh always said judges and juries put people away, and he was just doing his job. He did it well. He rang up convictions against members of organized crime in Western Pennsylvania, nailed a former Republican congressman (J. Irving Whalley), a Shapp cabinet member (Frank Hilton) and a Democratic state senator (Frank Mazzei), among others.

Thornburgh was smart, too: Yale grad, a University of Pittsburgh Law School honors grad and a stickler for detail.

And he was a moderate. In fact, he became interested in direct involvement in politics only after Republicans nominated Arizona's Barry Goldwater in 1964 at the Cow Palace in San Francisco and after he watched Goldwater buried in that year's General Election.

Lyndon Johnson pounded Goldwater by a nearly unimaginable margin of 61–38 and an even more impressive 90 percent of the Electoral College, beating Goldwater 486–52.

Thornburgh blamed the mess on "Republican moderates who sat on their duffs and let extremists from the far right take over."

As you can see, he was also prophetic.

And, ironically, there was a seventeen-year-old kid watching his father try a last-minute, off-his-duff effort to deny Goldwater the nomination. The father was wealthy, revered Pennsylvania governor William W. Scranton. The kid was William W. Scranton III, who Thornburgh would tap as his choice for lieutenant governor fourteen years later—which gets me to how I got from Thornburgh to Casey.

ME AND THREE STICKS

During the '78 campaign, I was a public affairs producer for WITF-TV, a PBS affiliate in Hershey, not far from Harrisburg, and also writing political pieces for in-state magazines while stringing for the *Washington Post.*

Philadelphia Magazine asked me to profile young Bill Scranton, GOP candidate for lieutenant governor, and sent along a copy of his resume. It was

thin. I remember seeing Yale, Switzerland and Transcendental Meditation. And I remember thinking this could be fun.

Philly Mag always liked fun pieces.

In fleshing out the story, what began to emerge looked something like this: WWWIII, some tagged him "Billy Three Sticks," a fifth-generation scion to a family that founded, built and all but owned the industrial northeast of Pennsylvania and Lackawanna County where the county seat bears the family name wanted more.

(Once, before a taped TV interview in Altoona, a local reporter asked him off-camera where he was from. "Scranton," he said. "Oh," she said, "just like your name.")

He went to Hotchkiss Prep in Connecticut, graduated from Yale in '69, but instead of a predictable path to law school or an MBA, he ran some small weekly newspapers near the old hometown, endorsed liberal Democrat George McGovern in 1972 (which, of course, raised Republican eyebrows) and then headed for Lake Lucerne, Switzerland, and the World Plan Executive Council, which taught TM for rehabilitation purposes. Scranton's wife, Coral Vange Scranton, who spent many of her younger years outside the United States, the daughter of an overseas General Motors vice president, also was a TM practitioner and teacher. Both studied with the Maharishi Mahesh Yogi, who taught TM to the Beatles. We'll hear more of him later.

Scranton, in short, was not your typical Republican. So off I went with a storyline in mind.

But after spending time with Scranton, then thirty-one, I was impressed. He was easygoing, comfortable talking about his wealth, his political family and TM, which he said he did twice a day for twenty minutes. I noted in the magazine piece that a colleague suggested Scranton's mantra might be "mmmoney, mmmoney." *money?*

Scranton wouldn't tell me what it really was.

But we did talk at length about TM. This was another irony, given what would happen eight years later (which I'll get to). When I started questioning him on the topic, he said, "You mean 'the flake factor.'" And here's what he told me in 1978 when I asked if he'd concede that a chanting, yoga-type meditation regimen might cause him problems running in a state as traditional and staid as Pennsylvania.

"Look, it's not a religion. It entails no beliefs or worship. But it is a part of my life and if that's the overwhelming impression people get of me, that I'm some kind of flake, there really isn't much I can do about it."

suspicions
always seem
to turn out true

That turned out to be true. I mean the part about not being able to do much about it.

We stayed in touch, and I interviewed him multiple times, including on-camera for two public TV documentaries. One was on the nuclear accident at Three Mile Island (TMI) and aired nationally on PBS.

The accident occurred in March 1979 shortly after Thornburgh and Scranton took office. TMI is close to Harrisburg and Hershey. Scranton, by virtue of his office, was head of the Pennsylvania Emergency Management Agency and therefore among the first government responders. He and his then-pregnant wife were early-on visitors to the plant, part of efforts to restore calm to the region, which, as I recall, needed some calming.

I remember filing accident-related material to the *Washington Post*, where the science editor asked me, "Why are you still there?"

But let's fast forward. For that question was a good one. After Thornburgh and Scranton won reelection in 1982, it was evident Scranton would run for governor in 1986. (Pennsylvania limits governors to two terms.) He and I talked. I was ready for a change.

So, although I loved working in public television and left on good terms, I left nonetheless and went to work for Scranton as his press secretary.

He was young, intelligent and articulate. He understood ongoing shifts in the state economy and knew it had to move from its manufacturing base to a broader information and technology base. He would lead the charge. He would offer the old rust-belt state a version of the New Frontier.

He drew immediate attention. He was a sought-after interview at the 1984 GOP convention in Dallas. *U.S. News & World Report* named him one of ten "rising stars of American politics." So he was an immediate front-runner, and his family name and money made him an obvious and a formidable one. In fact, he used to joke that his candidacy for governor was "historically inevitable."

THE 1986 CAMPAIGN

It's hard to imagine now, but back then campaigns got little notice until after Labor Day and no intense notice until after the World Series in October.

The 1986 race between Republican Scranton and Democrat Bob Casey, both of Scranton, was no different. For most of the year, it was assumed the younger, thirty-nine-year-old Scranton would win. He was already in

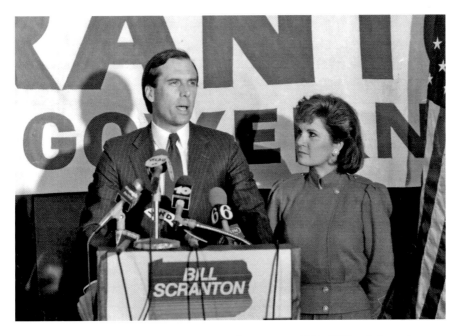

Bill Scranton, with wife, Coral, announces run for governor, 1986. *William Steinmetz/* Philadelphia Inquirer.

office and popular. He had a great name and drew favorable or at least not unfavorable press.

He was seen as an heir apparent, or "inevitable."

It also was assumed the older, fifty-four-year-old, more familiar Casey, who served two terms as state auditor general, who had a well-known and respected name but who lost in three previous attempts to win his own party's primary for governor (and picked up the moniker "The three-time loss from Holy Cross," his college alma mater) would lose again.

Scranton was something new. Casey was something old. Pennsylvania needed new energy for a new age. End of story.

Didn't turn out that way.

Turned out the campaign was the beginning of the story for one Chester James Carville Jr., a young, aggressive Louisiana-born marine and lawyer-turned-political-consultant who'd never managed a winning race.

Pennsylvania's 1986 contest would change that and set Carville, aka "the Ragin' Cajun," and his partner, Paul Begala, on their way to fame and riches.

They were hungry. And they had a little help from events and from the Scranton campaign. Three things happened that turned the tide to Casey.

Scranton might have survived one or even two, but he could not survive all three.

When the campaign was over, he lost by fewer than 80,000 votes out of more than 3 million cast.

I wrote about the race for *Philadelphia Magazine*. It wasn't a kiss-and-tell piece. It was a look at a campaign that drew national attention. It was politics from the inside out. And the three things that combined, in my view, to help elect Casey were highlighted in the article.

THREE AND THROUGH: THING ONE

The first thing happened on a Friday afternoon in early September. Scranton and I decided to visit the state capitol newsroom, a stone's throw from the lieutenant governor's office, which is just over the main entrance to the Capitol.

A bunch of reporters from a bunch of outlets from around the state, plus the wire service guys, gathered around, and Scranton, in shirt sleeves, sat on a desk near the center of the room and offered what in later years would be called "a media avail," as in availability.

The idea was to push some new economic numbers showing the state moving in the right direction, to talk about the general direction of the Scranton campaign and to reiterate Scranton's challenge to debate Casey on the economy before the end of the month.

In retrospect, we shouldn't have been so available.

Let me take you back. This is what I wrote about that afternoon:

> *It is almost time to wrap up when someone asks about Scranton's 1972 editorial endorsement of Casey for a second term as auditor general, an endorsement Scranton made when he ran three weekly newspapers in northeastern Pennsylvania. The answer, like most, is rehearsed. "One of the nice things about growing older," Scranton says, "is that you can leave behind the youthful indiscretions of your past." There are some chuckles, some note-taking. Then it happens. It comes in the form of a follow-up question from Bob Grotevant of the* Daily News. *"Speaking of youthful indiscretions…," he says, and then asks about past drug use, but without being specific about any particular drug. Then (UPI's Thom) Cole has his turn.*

He is lounging at a desk, not his own, and as Scranton tries to get away, Cole calls out above the crowd with the inquiry about pot.

His question, and the fact that Scranton never directly answers it, will become public knowledge within two hours as the tag on a story by the Associated Press. Before nightfall, the story will move on the national wire and bring Scranton some unwanted national attention. Ironically, Cole's own story for UPI barely touches on the question of drugs, an issue Scranton has faced before and often discussed during his eight years in public office.

At the time, we are unaware of its significance. We think it's old news. We think it will go away. Most of the other reporters in the room have talked with Scranton so many times before about drugs that it feels like a no-harm rehash or an old and tired subject. There is some irony to all this: how many men and women who attended college in the '60's—be they candidates for public office or news reporters—did not use marijuana at least occasionally? Still, it is a legitimate inquiry. And so the reporters press on. They ask again: he answers again. They push. He holds his ground. In 10 minutes of back and forth on the what, when, how, where and why of drugs, he jousts with words but says nothing new. The only tense moment—and you can see his jaw tighten—comes when he's asked if his campaign pollsters are asking questions to determine voters' reactions to the idea of a major candidate who has used drugs in his youth. "No," Scranton says. The correct answer is yes. The truth is he doesn't really know.

Walking back to the office, the candidate is seething—not because of the questions on drugs, but because he suspects his pollster is doing what Scranton just assured the press he wasn't. He wants it fixed. "Damnit, I will not lie. Find out what we're asking and deal with it."

"Why didn't you say, I don't know?" an aide asks.

"I don't know." Scranton turns sullen.

—Philadelphia Magazine, *January 1987*

Then came the fallout.

Just before 6:00 p.m. that Friday, AP moved a 450-word story slugged "SCRANTON DRUGS." The opening paragraph read, "Republican gubernatorial candidate William W. Scranton III said Friday he used recreational drugs when he was younger but he declined to name any of the substances."

Again, his youthful drug use was common knowledge, old news.

But at 10:15 that night, CBS radio in New York called for an interview with Scranton about drugs. I say, look, he had a long week, he's an early riser, he's probably already in bed and I won't disturb him.

What I'm thinking is "please go away."

How about you, the chirpy radio reporter asks. Can we get some quotes from you? I say something like call me back in twenty minutes if you still think you need something. I say this half hoping that within those twenty minutes something big happens in Manhattan or the 1986 New York Mets publicly guarantee a World Series win.

(They did win that year, by the way. Glad somebody did.)

But, sure enough, CBS calls back, and I do a few innocuous quotes suggesting the drug-use story is old, been told before, has nothing to do with Scranton today and please don't tell any TV people (that last thing I said only in my mind).

Then the news gods intervened.

The CBS radio story was set to run Saturday morning but was dropped after four Pakistani terrorists highjacked a Pan Am jet en route from Pakistan to Germany. Twenty passengers were killed, much bigger news.

Back in Pennsylvania, however, "SCRANTON DRUGS" gets pretty good play across the state in print. Better on a Saturday in September, I think. Better still if the subject of drugs wasn't already part of the national dialogue ever since twenty-two-year-old University of Maryland all-American basketball player Len Bias, a Boston Celtics draft choice, died of a cocaine overdose in his college dorm in June.

So drugs won't go away.

The following week, a Lancaster reporter asks Scranton if he'll take a drug test.

Of course he will. I mean what? You're gonna say no? It's set up quickly and quietly as part of an annual physical. Our plan is to hold the results unless or until asked about them. That happens a week later when the *Pittsburgh Press* asks.

Scranton is clean. No harm done beyond a little indignity. And nothing close to what lies ahead.

Like a pro-Casey act of God, *Time* and *Newsweek* run cover stories on drug abuse, and this was at a time when lots and lots of people read *Time* and *Newsweek*. Then Ronald and Nancy Reagan deliver a prime-time message to the nation to "just say no" to drugs. Perfect.

Then CBS-TV calls. (I knew I shoulda said that thing in my head out loud.) We decline to be interviewed.

Next, we meet with our pollster, Dick Wirthlin, also President Reagan's pollster, who says the race is tightening.

And the drug issue is sticking.

There are fliers, a cartoon of Scranton as a hippie with a collage of "SCRANTON DRUGS" headlines, showing up around the state, especially in rural Republican counties that should be Scranton's base. There are rumors he burned his draft card (he didn't). And in Pittsburgh, a TV reporter interviewing Scranton pulls out a poster on camera that shows a long-haired young man smoking pot saying, "If my daddy gave me a million bucks, I'd run for office, too."

The reporter asks Scranton what he thinks. Scranton calls it garbage. But what he really thinks is there's more to come and that means we're in trouble.

A CHANGE IN DIRECTION, WHICH LEADS TO THING TWO

Both campaigns are airing TV ads, lots of them negative, mostly on issues, but there's a growing fear Carville and Casey will soon go at the personal stuff.

Remember, this is 1986 in a mostly socially conservative state, and our *Republican* candidate for governor admits to past drug use and current TM practice. Some of us felt we were sitting on a time bomb.

By mid-October, Scranton decides to stop the war and run only positive ads; we're leaving the low road and rolling the dice. Some call the move a mistake, a sign of weakness, throwing in the towel. No matter. He wants change.

So, in the basement of a broadcast production facility off DuPont Circle in Washington, D.C., we cut a new ad. It's Scranton to camera, talking directly to voters for thirty seconds. The ad is called "Stop."

The campaign for governor has deteriorated into an ugly name-calling contest. There's too much at stake for the people of Pennsylvania for this campaign to become a back-alley brawl. I have ordered my campaign to stop all negative advertising immediately. Win or lose, there will be no more negative ads from my campaign. Mudslinging is not leadership. I intend to give you the kind of campaign and the kind of leadership you deserve.

The screen goes black, big white letters say SCRANTON, the ad is over and the campaign takes off. The ad wins support and editorial praise. The *Washington Post* writes about it. *New York Times* columnist Tom Wicker writes about it under the headline "The Road Not Taken." And the *Wall*

Street Journal says the ad turned Pennsylvania into "an important political laboratory" by taking "the biggest gamble in American politics." Everyone relaxes. Everyone feels good. And then we all get bit in the ass.

THING TWO

This comes in the form of a piece of direct mail, well, actually 600,000 pieces of direct mail, made up well before anyone ever imagined we'd be running a positive campaign.

On Saturday, October 25, an AP reporter calls and asks if our all-positive pledge extended to direct mail. Such a question at such a time drew the only possible response. Shit.

The reporter, Rod Snyder, says there's a Scranton mailer that swipes at Casey, that says when Casey was auditor general in the scandal-plagued Shapp administration, Casey was "blind to the fraud, abuse and corruption" because he was "too busy making $100,000 a year" practicing law instead of being "a full-time auditor general."

I tell Snyder the truth, which is I know nothing about the mailer. I say I'll find out what I can and call back soon.

During my search for facts, Tom Ferrick, lead political reporter for the *Philadelphia Inquirer* calls and says something like, "I think you guys goofed and I think I have to write it."

I point out that it's a beautiful fall day and there are doubtless several collegiate football games underway in the greater Philadelphia area and that maybe his time would be better spent as a sports spectator than a destroyer of campaigns.

For some reason, he disregards my suggestion.

This development is about as bad as can be. Not only did we violate our own pledge, we also overshot the negativity. The money Casey made from his law firm wasn't made in a year. It was made over a four-year period.

The only good news is the campaign had ordered the mailers NOT to be mailed. But, since good news is no news, the story plays big and the Casey camp calls Scranton a hypocrite.

Casey refuses to do a pre-scheduled joint appearance with Scranton before the *Pittsburgh Post-Gazette* editorial board, saying he won't sit down with someone who says one thing but does another.

Casey holds a news conference standing in front of 600,000 envelopes asking how anyone could make a mistake so huge.

The question becomes can we hang on to the finish?

We have a strong ad rotation for the final week. It includes pretty-pictures-with-nice-music ads of Scranton, his wife and three young daughters. It strongly suggests that such a fine-looking father and husband could never be a druggie or a flake. There's also a spot with quotes from seventeen daily newspapers that told voters Scranton should be their next governor. And there's an endorsement ad by President Reagan to help the GOP base see that it's okay to vote for Bill.

And then came THING THREE.

THE GURU AD

On the Friday before Election Day, when all ad buys were locked in and the Scranton campaign could not respond, Carville and team Casey ran a thirty-second spot that hit Scranton between the eyes (some would say between the legs).

It incorporated all the elements of a politically effective negative ad. It started, rather than ended, with the disclosure that it was paid for by the Casey campaign. It opened with no sound, just the words "CASEY" and "GOVERNOR." Then there was sitar music and a female voice over black and white photos of a younger Scranton with long hair, then a full-screen, full-face shot of the Maharishi Mahesh Yogi. This is what the female voice said:

> *Is Bill Scranton qualified to be governor?*
>
> *After college, he bought three newspapers with family money, but he stopped going to work and the papers failed.*
>
> *Scranton joined Transcendental Meditation and became a disciple of the Maharishi Mahesh Yogi.*
>
> Time Magazine *said Scranton traveled the world evangelizing for Transcendental Meditation, and he said his goal was to bring Transcendental Meditation to state government.*
>
> *His only real job was lieutenant governor, and they gave him that because of his father's name.*

The ad ran everywhere except Philadelphia and clearly was aimed at scaring off older Republican voters, especially in rural counties.

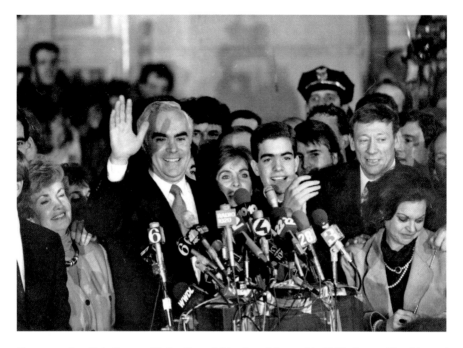

Governor-elect Bob Casey, with family and friends, celebrates his 1986 victory. *Clem Murray/* Philadelphia Inquirer.

Scranton answered its assertions point by point: he did not use "family money" to buy the newspapers. He took out a loan to assume their liabilities. They did not fail. He put them in the black. And, in 1986, they were still there. He discussed TM many times but never tried to bring it to state government beyond suggesting it as a relaxation technique in prisons. Nobody "gave" him his public office. He was elected in a contested primary.

But facts and substance are not great survivors of elective politics. Plus, words such as "disciple" and "evangelizing" mixed well with the images; and images tend to work. In this case, they worked through the weekend and through Monday and Tuesday. They worked well enough to help Bob Casey win the governorship. And when added to "SCRANTON DRUGS" and 600,000 pieces of direct mail, they worked to set me on a return path to journalism.

RETURN FROM THE DARK SIDE

In truth, there was little I liked or enjoyed about working inside politics. The adrenaline rush of the closing weeks of a tight campaign was fun and a valuable experience. And throughout my stint I learned a lot about government and the press, not all of it positive. Too much of government revolved around decisions made to benefit elected officials or their financial supporters first and the public second, and sometimes only coincidentally. Too much of the press was superficial, seeking easy-get headlines, interested more in sound bites than substance.

Still between the two fields, I sided with and was drawn to the one that I believe has at least the goal of getting citizens and voters as close to the truth of any issue as possible, as opposed to the one whose goal is getting citizens to vote for one person rather than another, regardless of the truth.

Government and especially politics, I learned, was not an arena I intended to stay in no matter of the outcome of the race.

So I reached out to Pennsylvania's four major newspapers: the *Pittsburgh Press*, the *Pittsburgh Post-Gazette*, the *Philadelphia Inquirer* and the *Philadelphia Daily News*. I got one interview, with then-editor of the *Daily News*, Zack Stalberg. (I've since referred to him as my personal lord and savior; he now runs Philly's Committee of Seventy, a long-established public advocacy group.) We talked. I pushed the point that I was not ideological. That I missed being in the media. That it was more fun to ask questions than to answer them. And that what I had learned inside the political machine, especially with regard to forming public policy, would make me a better journalist than had I been before.

There was no quick decision, but two things happened that I believe helped my cause.

First, Casey hired *Daily News* Capitol reporter Bob Grotevant as his press secretary. And then, in January, two days after Casey was sworn into office, state treasurer Budd Dwyer publicly committed suicide by putting a .357 magnum in his mouth and pulling the trigger during a Harrisburg press conference.

It was one day before he was to be sentenced to prison after being convicted of accepting a $300,000 bribe from a California-based firm, Computer Technology Associates, in exchange for a multi-million-dollar state contract.

It was, of course, a national story.

Dwyer always proclaimed his innocence, and many believe he killed himself in order to allow his family to collect his considerable state pension benefits, which under state law he would have forfeited upon sentencing.

So the *Daily News* had both an opening in Harrisburg and a reminder that real news can happen there. Also, because I now know how Stalberg thinks (we've been friends for years), I'm certain he was sending a message from the *Daily News* to the new Casey administration: if you think because you hired one of ours we'll be soft on you, or if anyone thinks you hired him because he was soft on you, here's his replacement.

I got the job within a few weeks.

I should mention that while the shuttle between press and politics is common now, it was rare back then. So I wouldn't say I was welcomed to the Capitol Newsroom. And I can say, without reservation, the Casey administration was less than pleased to have me there.

Still, there I was, kicking off what would become a long *Daily News* career covering politics in the great state of Pennsylvania.

THE REAL BOB CASEY

By the time Casey took office, he'd been in and around politics twenty years and had run for governor four times. Because of his stints in the state Senate and as auditor general, his name was so well known that another Bob Casey (from Johnstown) won a term as state treasurer in 1976 by not campaigning and a third Bob Casey (from Pittsburgh) won the Democratic primary for lieutenant governor in 1978.

So Casey's campaign finance committee bore the clever name, "The Real Bob Casey Committee."

I'd covered Casey while at the Harrisburg *Patriot*, always got along with him and, despite what he and/or aides likely believed, bore him no ill will as I started covering him for the *Daily News*. I was ready to move on. I was ready to be a journalist again.

And Casey's first year made for good copy.

He arrived with an agenda stressing economic growth, educational opportunities and environmental improvements, all under the promised leadership of a "strong and compassionate" administration.

Problem was, there were problems—as there are in any new administration—and there was a sense the Casey team was surprised to have won the election and not really prepared to govern.

In fairness, this might well have been more my sense than anybody else's.

His first budget included a $12,000-a-year raise for lawmakers—making the largest full-time legislature in the nation also the highest paid—and a raise for the governor.

Nonetheless, the governor and lawmakers had a series of run-ins over key elements of his priorities and, especially, his oft-stated, tough-guy claim that he "didn't come to town to do things the old-fashioned way!"

He was a political mix of old-line Democratic pro-labor views and pro-life, pro-gun, social conservative beliefs. His strongest supporters were the same "Casey Democrats" in rural southwestern and northeastern smaller cities and towns that had been "Reagan Democrats" in the 1980 presidential election.

He was a staunch Catholic, a lawyer and father of eight, a plain-spoken son of the coal regions (his father started in the coal mines then went to law school) and, first and foremost, a self-described "fighter."

Many times he'd remind the press, "You're looking at the toughest cat in town."

He would prove that more than once.

TWO KINDS OF IRISH

Casey's problems getting along with the legislature spilled out in public on a regular basis. One high-profile spill was after a ceremonial legislative session in September 1987 on Philadelphia's Independence Mall.

The session was held in the Constitution Pavilion in honor of the 200th anniversary of the first public reading of the U.S. Constitution. It was the first time the legislature met outside Harrisburg since the Capitol was located there in 1812. Former U.S. Supreme Court justice Warren Burger was the featured speaker. And, of course, the governor spoke.

A lot of lawmakers didn't like what he said.

He compared environmental problems facing the state, especially water quality issues, to the crises faced by the framers of the Constitution. He chided lawmakers for inaction, called for a bipartisan push to pass a $650 million clean-water proposal, said he wanted it done by the end of the year and noted it only took four months to write the Constitution.

"When it comes to the health of this and future generations," Casey said, "our people have no patience for politics as usual, and neither do I."

He delivered the remarks with his normal, stern, dark Irish scowl. And after his speech he told reporters that lawmakers should "get off their rear ends and do something…I'm throwing down the gauntlet today."

Republican Senate leaders and even some Democrats called Casey's comments a "sour note" on a day of ceremony, "way out of line" and "embarrassing."

A QUICK ASIDE

Philly Democratic representative David Richardson, who at the time was president of the National Black Committee of State Legislators, was denied a request to address the ceremonial session on the issue of what he called the absence of black and African culture in the celebration and society in general. So afterward, he stood on a cement bench adjacent to the pavilion and read a statement saying, in part, that African Americans are not included in "We the People," decrying the social and economic conditions of too many African Americans and calling on the legislature to promote textbooks, films and TV programs featuring African culture and contributions by blacks. He read this statement by himself, ignored by the media—except for me—with state representative Gordon Linton, then-chairman of the legislature's black caucus, standing beside the bench. My article on this ran the next day under the headline "Red, White & Blue, But Where's the Black?"

After Richardson died of a heart attack at age forty-seven in 1995, I wrote a column saying that the speech on the bench captured Richardson perfectly; that maybe he didn't change the world but, by God, he yelled at it.

I also wrote that when his House colleagues returned to session from summer break, they would find the fourth chair from the rear of the ornate House chamber on the Democratic side of the aisle draped in black in Richardson's memory. When they did, I suggested they look at it long and hard and remember David and ask themselves, "What am I doing here?"

For he never had to ask that, nor did anyone who knew him. After his bench speech, I asked him if he was annoyed that the media at large ignored him. This is what he said: "My purpose was to make a statement, and I've done that."

A few weeks later on October 1, Casey underwent a four-and-a-half-hour quadruple heart bypass at the Penn State Hershey Medical Center, the first of what would be two major health issues he faced while in office.

A few Casey insiders privately blamed lawmakers. A few lawmakers blamed Casey's quick-triggered temper.

And just before he returned to work in November of that year, Casey summoned state media to the Governor's Mansion, about a mile from the Capitol, and displayed some of that temper.

Talking tough and raising his voice, he vowed to win tax reforms that others "copped out" on for fifty years.

"I'm not short-winded," he said, "You're looking at a marathon runner. You're looking at a fighter. I didn't get here by being weak-kneed."

Asked about problems with the legislature, he said, "What should I do, go over and vote? My God, what else can I do?"

Such was Robert P. Casey.

The best explanation I ever got for the rift twixt Casey and lawmakers (not that virtually every governor at some point doesn't have one) came from former Democratic House Speaker Bob O'Donnell of Philadelphia.

O'Donnell said Casey held a cocktail party for a group of legislators at the mansion to try to break the ice.

Casey asked O'Donnell what he thought the main problem was, and O'Donnell said, "There are two kinds of Irish: those that breed the poets, the drunks and the politicians; and those that breed the priests. We are mostly the former. I'm afraid you, lad, are the latter."

The best example I ever heard of Casey's legendary all-business, often-intimidating workplace reputation was from former Casey aide Pat Boyles.

He nervously accompanied Casey on a spring Saturday to Bloomsburg University where the governor was commencement speaker.

Afterward, it was Casey, Boyles and a state trooper in the car heading home to Scranton. After riding in silence for maybe thirty minutes along busy I-81, Boyles ventures small talk. He offers an observation along the lines of, "There sure are a lot of cars from out of state."

Casey, reading a newspaper, slowly and deliberately responds without looking up, "Pat, that's why they call it an interstate."

There was silence the rest of the trip.

When Boyles confirmed the story for me, he said of Casey, "He certainly was intense."

ONWARD AND UPWARD (AND THEN DOWN)

Casey had a good second year: a $2.5 billion program to create an Infrastructure Investment Authority to improve drinking water and sewage-treatment systems; a recycling law, making Pennsylvania the first large state to enact one; and a hazardous waste site cleanup law.

He even got to speak at the Democratic Convention in Atlanta in July. For five minutes. Before network TV coverage started. But compared to what would happen to Casey at the next Democratic convention (in New York in 1992), that five minutes was a big deal.

Then he had a stunning win in November when he signed a local tax reform law allowing municipalities and school districts to collect higher income taxes in exchange for lowering property taxes—the latter being a forever issue because of the state's aging population.

Problem was, his plan died in a voter referendum the following May (1989) by a shocking three-to-one margin after being labeled as simply tax-shifting.

But Casey scored another win and landed loads of national attention by fighting for and signing into law some of the nation's toughest anti-abortion measures, most of which eventually were upheld by the U.S. Supreme Court.

In 1990, he was reelected by the one of largest margins in state history, beating abortion-rights Republican Barbara Hafer, then the state's auditor general, in a contest marked by two things: Hafer called Casey "a redneck Irishman," and she predicted the state would face a $1 billion deficit in 1991.

She was right about one thing. And '91 was not a good year for Casey.

In July, he announced he had an extremely rare genetic disease, familial amyloidosis, which shows no evident early symptoms but is life-threatening.

Oddly, a more aggressive variety of the same disease killed two other Pennsylvania politicians, Erie mayor Lou Tullio in 1988 and Pittsburgh mayor Dick Caliguiri in 1990. It seemed as if the state was cursed.

Then in August, after an extended legislative budget battle, Casey signed a spending plan that included $2.86 billion in new taxes to cover Hafer's prediction and then some.

The income tax, gas tax, cigarette tax and business taxes all went up, and the state sales tax was extended to things such as lawn care, cable TV and computer services.

Casey had some rough days ahead and would also make more national news.

Some of it was connected to his health and his extraordinary comeback from a double-organ transplant. Some was related to his public spats over abortion with his own party and its presidential candidate, William Jefferson Clinton.

All of it made for a good time to be a political journalist in the Keystone State.

CHAPTER 3

The Casey Years
(and Lots of Political Doings)

The 1990s in Pennsylvania got off to an extraordinary start and included events that would alter the state's political landscape.

It was a decade in which politics suffered and grew through deaths, illness, birth and rebirth.

In April '91, incumbent Republican senator H. John Heinz III, heir to the Pittsburgh-based worldwide food company, died in an air crash over an elementary school outside Philadelphia.

A helicopter sent to check a reported problem with landing gear on a small Piper Aerostar carrying Heinz got too close. There was a mid-air collision. Heinz and six others, including two first-graders on the school playground, were killed.

He was fifty-two.

I remember calling everyone in my Rolodex (we had Rolodexes then) for reaction. But neither I nor anyone I talked with that day could have predicted how impactful that death would be on state and possibly national politics.

Had Heinz lived, it could be argued, there might never have been a senator (later presidential candidate) Rick Santorum. And quite likely other careers would have been different, or nonexistent.

Heinz was a moderate who intended to run for governor in '94 on the theory it would be easier to later run for president from that office than from the Senate.

It was and is a good theory. And Heinz, because of his money, name, looks and political skill, could have been a GOP leader and, if not someday his party's presidential nominee, one of its major players.

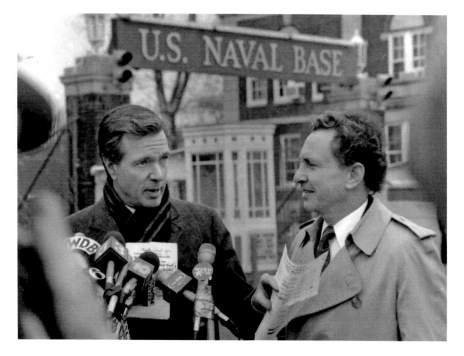

Senators John Heinz and Arlen Specter at a 1990 Philadelphia Naval Yard news conference. *Sharon Wohlmuth/*Philadelphia Inquirer.

Maybe his influence would have prevented, muted or delayed the GOP's later rush to the hard political right. Or, he might have switched parties and become a leading Democrat.

He seemed destined to succeed.

I first wrote about him in detail for *Philadelphia Magazine.* The piece was titled "Born to Win" and focused on his first Senate race in 1976. He won the GOP nomination in a six-way primary. The second-place finisher was the ever-present, ever-available (wait for it) Arlen Specter.

Heinz then ran against Philadelphia's Bill Green. Both were in Congress. Both came from famous families at either end of the state: Heinz's ran a corporate giant, Green's a political one

The race drew national attention and set Heinz on a path so many expected he'd always travel.

Here's an excerpt from my take on the candidates.

Looking at H. John Heinz III and William J. Green III is like looking at a pair of matched political bookends. They are perfect candidates. Heirs

to families of force. Inheritors of prestige and open doors. They have been "promising" politicians for years. Heinz, Republican, Pittsburgh. Green, Democrat, Philadelphia. Opposite ends of the shelf, and now one will be knocked off.

But which one? With so many similarities on what basis will voters decide?

Both Heinz and Green will be 38 years old by Election Day. Each has a beautiful wife and three picture-book children. When Green was first elected to Congress at age 25, he was the youngest person ever voted into the office. When Heinz was elected, at 33, he was the youngest Republican. Both won their House seats in special elections. Each succeeded veteran congressmen who died in office... (and) neither had to work very hard to do it. The power of the Green Machine in Philadelphia politics is legend. And the name Heinz is known to anybody, anywhere who ever put ketchup on a hamburger or ate a pickle. In short they were born to win.

In style, appearance and the catch-all called image, the two men are nearly carbon copies. They are tall, dark and handsome types. They are both about the same height and weight; both trim and fit; both impeccable dressers. They are exceptionally effective campaigners, having won their respective congressional districts by vote margins that top 70% of the total ballots. As a result, each has faced a few opponents who best can be described as political kamikazes.

Both are well-bred, educated, articulate. Their voting records in Congress are relatively safe. Neither is philosophically offensive. Heinz is a moderate-to-liberal. Green is a liberal. Both are excellent debaters—good with words and they know it—and fiercely competitive...then there's money. Heinz has it and so does Green. But that's like saying that Noah and Gene Kelly both had rain.

—Philadelphia Magazine, *October 1976*

Heinz outspent Green and won narrowly in a Democrat year (Jimmy Carter's election) with 52 percent of the vote.

BACK TO 1991

After Heinz's death, Casey appointed Harris Wofford, his secretary of labor and industry, to the Senate. The pick was a stunner and came after a

month-long search. At least ten others were considered, including Chrysler Corporation boss Lee Iacocca, who didn't even live in the state but who was born in Allentown and widely known because of his TV commercials.

Many Democratic insiders were furious with Casey for tapping the unknown Wofford. He never held nor ran for office and, importantly, he wasn't from Western Pennsylvania, an area of profound regional loyalty that just lost a senator and wanted a new one.

On the other hand, Wofford sported top liberal credentials: civil rights advisor to Martin Luther King; special assistant to President Kennedy; deeply involved in starting the Peace Corps; president of Pennsylvania's Bryn Mawr College; and chairman of the state Democratic Party.

Wofford went to the Senate in May '91 but had to win the seat in a special election later that year. He would run against former governor and, by then, former U.S. attorney general Dick Thornburgh, who was expected to win with ease.

Wofford was a soft intellectual; Thornburgh a hardened politician with edges sharpened in two statewide campaigns and a stint in national office.

Thornburgh had been a governor who got high marks for his calm handling of the Three Mile Island nuclear accident. As U.S. attorney general, he was on shortlists for vice president in 1988. In May 1989, he graced the cover of the *New York Times Magazine* and was viewed as a potential presidential candidate someday.

But then he had a leak problem. CBS News reported that his Justice Department was investigating a powerful Pennsylvania congressman, William Gray III, a Philadelphia Democrat (notice how many Pennsylvania pols are IIIs?), for financial irregularities. This was 1989. The report came just as Gray, an African American, was campaigning to be House majority whip, a post he won and held until he stunned the political world by resigning from Congress in 1991 to head the United Negro College Fund.

Point is the leak of this "investigation" was seen as political and, by some, racially tainted. It wasn't pretty. Thornburgh ordered an investigation and vowed to get to the bottom of things. He was so serious he took a polygraph. Imagine an attorney general with a reputation for integrity strapped to a lie detector.

He passed.

But two of his top aides, David Runkle and Robert "Robin" Ross, did not. Both were reassigned to lesser posts. Not that they were sources of the leak (speculation was it came from a retired FBI agent), but Runkle confirmed the existence of an investigation and Ross was aware of that confirmation.

Afterward, Thornburgh and his agency cracked down on leaks and on dealing with the press; and there were those in the national media who didn't like it.

Stories started sprouting about Thornburgh's over-zealous need for control and planning his own political future. It got to the point the *Washington Journalism Review* ran an article, "General Thornburgh Cuts off the Press."

When I interviewed Thornburgh in the attorney general's office in 1990, he said this:

> *There's a lot of leaking that goes on in Washington. At Justice now there is a lot less than there used to be...(that) specifically caused the national press to take a retaliatory attitude; that's the price we're paying...We have gotten bad press, a lot of which is based on rumor, innuendo and desire of others to tarnish this office and its occupant. That goes with the territory. I don't like bad press. Nobody does. But the immediate logical alternative is unthinkable.*

The following year, Thornburgh resigned to run for Senate. The leak thing was largely an inside-the-beltway story. He remained popular in

U.S. Attorney General Thornburgh in his Washington office before his Senate run. Philadelphia Inquirer.

Pennsylvania. When the race started, he held a forty-point lead over the lesser-known Wofford.

But Thornburgh, I believe, never wanted to be a senator. He ran an awful campaign based on not losing rather than winning. It seemed to rely solely on name ID.

On the trail, Thornburgh was quick to anger and sometimes sullen, as if burdened by the task. It didn't help when a top aide, Michele Davis, was quoted saying Thornburgh represented "the salvation of this sorry-ass state."

(The *Daily News* headline on my short story was "Maybe She Meant, 'Sorry, Ask Kate.'")

Conversely, Wofford was enthusiastic and upbeat. He wanted nothing more than to remain a senator. Loved the job. Loved the club. Loved waxing on about any policy anyone cared to discuss.

And, lucky for him, he had a secret weapon—the same James Carville who helped elect the real Bob Casey was Wofford's manager. Carville called reporters covering the contest on an almost daily basis. The Thornburgh camp, not so much. Not that Carville offered insider tips or opposition research. He simply showed constant interest.

Here's a sample, almost verbatim, of regular calls to me:

"Baer? (Except with his southern accent it was more like 'Bayer?')

"Hello, James."

"It's Cahville."

"I know. How are you?"

"Bayer, what are they (the Thornburgh campaign) dooin'? I mean whaddya YOU think they're dooin'? I mean, if you were them wouldn't you be dooin' sumpthin'?"

"I don't know what to tell you, James."

"Okay, gotta go. Bah (as in goodbye)."

The race turned into a canary in the coal mine for President George H.W. Bush (who would lose the presidency the very next year) as Wofford ran against Bush policies and the need, "the right," to available, affordable health care.

It was something to watch.

Thornburgh lost by double digits in what Carville dubbed "an upset landslide," and what I described as a whooping up and down the Pennsylvania Turnpike.

Harris Wofford became the first Democratic senator elected from Pennsylvania in thirty years and happily returned to Washington. He had

Harris Wofford in Philadelphia at a 1991 Senate campaign news conference. *Charles Fox/ Philadelphia Inquirer.*

no inkling there was a freshman congressman from Pittsburgh waiting to replace him.

BACK TO CASEY
(AND OTHER POLITICAL BOMBSHELLS)

Just as the shock of Heinz's death was wearing off came two more stunners.

In July, Frank Rizzo, a political icon, the former tough-as-nails Philadelphia police commissioner and later two-term Democratic mayor, dropped dead of a massive heart attack.

This came while he was mounting a comeback, running as a Republican for mayor. His opponent was former Philly district attorney Edward G. Rendell.

After Rizzo died and was replaced on the ballot by lesser-known Republican Joseph Egan, Rendell went on to win the mayoralty and serve two terms.

It was another case of a death perhaps altering the path and career of multiple pols, including Rendell.

And the hits kept coming.

One week after Rizzo died, Casey held a news conference to announce he had an incurable genetic disease (familial amyloidosis); a disease so rare only about forty people nationwide ever had been diagnosed with it.

Casey made the announcement because of persistent rumors that he had cancer and was about to resign. Those rumors sprung from the fact that he looked horrible, thin and worn, and all who covered him or saw him frequently knew something was wrong.

Philadelphia Inquirer reporter Fred Cusick once casually asked the governor in a Capitol hallway, "So, do you have cancer?" Casey answered, "No."

On the day of the announcement, physicians at his side, the governor insisted he felt fine and would finish the three and a half years remaining in his second term. It was explained that the disease was slowly hardening one wall of his heart but that he had no immediate threat, could be treated and was under no restrictions.

Said Casey, "I'm going to be around for a while, like it or not."

Then he signed that $2.86 billion tax hike, and a lot of people didn't like it.

AN ASIDE: A SHAKE-YOUR-HEAD STORY

I can't get too far ahead of 1990 without a remarkable story of legislative abuse.

It's an example of how the legislature is designed to benefit its members, perhaps more so than in any other state.

I spent months in the summer of '90 going through paper files of Philadelphia lawmakers' expenses for a package of stories on the city's delegation.

What I found about one member was turned into a stand-alone story with a sidebar. What I found about the delegation showed the generosity of legislative expenses and little monitoring thereof.

Remember, these are 1990 dollars.

During an eighteen-month period covering most of a legislative session, the average monthly expense collected by each of the thirty-six city members was $2,915.

One member, Democrat Mark Cohen, collected an average of $5,200.

Cohen collected a total of $104,175. Nobody else in the 253-member legislature came close. And every reimbursement Cohen got was perfectly permissible under legislative rules.

How'd he do it?

The largest chunk came from "per diem" expenses, money paid to lawmakers to cover travel-related costs such as meals and lodging. No receipts are required. A lawmaker simply claims he or she is working on any given day and submits a claim for a "per diem."

For many lawmakers from around the state who share living quarters while in Harrisburg and dine out on lobbyists' tabs, this perk can be like a second job.

For Cohen, it was a second career.

He made $44,062 in per diems by claiming he worked and/or traveled on 501 days during the eighteen-month period. This included weekends and holidays. Christmas Day, New Year's Day, Easter Sunday, Memorial Day, Labor Day and Yom Kippur.

Shaking your head?

When I asked about his unusual schedule, he told me, "I'm doing an awful lot of work. I'm here six, seven days a-week." When I asked what sort of work he did on weekends and holidays, he said, "Preparation."

His second biggest expense was airplane tickets—$10,984—to fly between Philadelphia and Harrisburg, a distance of about ninety-five miles. Most Philly-to-Burg commuters drove the Pennsylvania Turnpike or took the train. The Harrisburg Amtrak station is a few blocks from the Capitol.

When I asked why he flew, Cohen said, "I've found out that driving wears me out physically."

He was forty-one years old at the time.

He also charged $5,700 in parking fees, mostly at Philadelphia International Airport, and $5,350 for books and magazines, including "The Fall of Communism," a book club membership, a subscription to the *Columbia Journalism Review* and a $318 copy of the Philadelphia Real Estate Directory.

(Turns out he was just warming up. More than a decade later, Mario Cattabiani, then with the *Philadelphia Inquirer*, reported Cohen spent more than $28,000 in taxpayer money to buy eight hundred books during 2004 and 2005. My theory is real estate didn't work out so he opened a book store.)

The sidebar that went with the *Daily News* piece on Cohen carried the headline "Cohen for Broke: His Expenses Tops in State."

Here's what it said:

An example of state Rep. Mark Cohen's habit of working holidays and weekends and charging taxpayers for expenses can be pieced together through a look at records for just one day: April 15, 1990, Easter Sunday.

Veteran state House member Mark Cohen. *Carolyn Kaster/Associated Press.*

Cohen began the day by flying from Harrisburg to Philadelphia on a 7:15 a.m. flight. Cost: $90.

At 8:57 a.m. Cohen pays to get his car out of a Philadelphia International Airport Parking Garage, where it sat since March 30. Cost: $224.

He drives eight miles from the airport to an unknown destination, at 20-cents per mile. Cost: $1.60

That night, he drives back to the airport and charges mileage for 12 miles at 20-cents per mile. Cost: $2.40

Then he takes the 10 p.m. Sunday night flight back to Harrisburg. Cost: $90.

Once there, he pays to get another car out of the Harrisburg airport. Cost: $5.50.

He also charges a "per diem" expense for a legislative business day. Cost: $88.

The total day's cost: $503.50.

The Legislature was not in session.

And Cohen's math also got him $2 extra. Though he listed 12 miles and 8 miles, he submitted for 30 miles. The House paid the higher mileage amount.
—Philadelphia Daily News, *September 26, 1990*

Cohen's been reelected in every cycle since 1990. He is, as of this writing, a thirty-eight-year incumbent and remains a per diem king.

ON TO 1992

More upheaval and change came in '92, known nationally as "The Year of the Woman."

Pennsylvania was its epicenter.

That's because our old friend Arlen Specter finally made it to the U.S. Senate in 1980. He won an eight-way GOP primary with 36 percent of the vote.

(Many insiders teased that he loaded the field to improve his chances.)

He then won the General Election with 50.5 percent of the vote, beating Pittsburgh Democrat Pete Flaherty. And he was reelected in 1986, beating Philadelphia-area Democratic Congressman Bob Edgar 56–43. Edgar would later become CEO of Common Cause. Specter would later become a prime mover in creating "The Year of the Woman."

You no doubt recall Arlen as lead questioner (some said torturer) in '91 when the Senate Judiciary Committee held nationally televised hearings into

Oklahoma law professor Anita Hill's allegations of sexual harassment by U.S. Supreme Court nominee Clarence Thomas.

You know the story: Arlen roughed up a woman appearing before the Senate's men's club on a sex issue and came across as an insensitive, sexist thug.

The political view was that Arlen needed to help Thomas and appeal to the right after he had effectively blocked the high-court nomination of Judge Robert Bork, a darling of conservatives, for which Specter earned the nickname "Benedict Arlen."

The result of the Hill thing, however, surprised many and led to one of the most exciting political races in Pennsylvania history.

LYNN YEAKEL VS. ARLEN SPECTER

On a March morning in 1992, I'm sitting in the back of a bland hotel conference room near Grantville, a tiny rural community not far from Harrisburg in the south central part of the state.

There was a Thoroughbred race track there and little else.

Lynn Yeakel, a wealthy unknown from the Main Line suburbs of Philadelphia and a Democratic candidate for the Senate nomination to challenge Specter, is speaking. I'm the only journalist present.

Yeakel's a novice but has some props. She was a co-founder (in 1976) and later president of a non-profit called Women's Way. It's an organization that finds and feeds money to women's programs: shelters, job training, health and reproductive services.

As she's talking to a smallish, seemingly sedate group of women attending a conference on domestic violence, and as I'm fighting the urge to nod off, something happens.

Yeakel, with her voice slightly rising, says that Specter's questioning of Anita Hill "showed an absolute disrespect for women, period!"

The room erupts. I mean loudly. I mean like a thunderclap.

I think, what the hell was that?

And then, my friends, we were off to the races.

Yeakel starts out in the five-way Democratic primary at just 1 percent in the polls and not backed by the party. But she fans the Hill thing from a still-smoldering ember into a firestorm of support overtaking better-known Lieutenant Governor Mark Singel, whose candidacy turns out to be a bad idea.

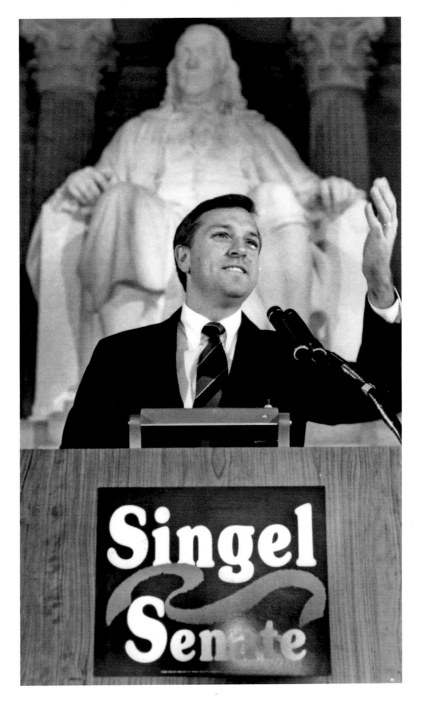

Mark Singel announces for the 1992 Senate race: a bad idea. *Juana Anderson*/Philadelphia Daily News.

She runs a statewide TV ad ignoring her primary opponents and going right at Specter. We see him questioning Hill. Then we hear Yeakel's voice ask voters, "Did this make you as angry as it made me?"

Evidently it did.

Yeakel comes from out of nowhere to win the primary. At an election night celebration in Philadelphia, a supporter hands her a sign. She laughs and holds it up. It reads, "Look out, Arlen, here she comes!"

Suddenly she's a national story. Suddenly her campaign has more emotional charge than other women's campaigns such as Carol Moseley Braun's in Illinois or Barbara Boxer's or Diane Feinstein's in California. And it's because she's running against that man, the one who so helped ignite the ember.

The odd thing? Specter had a solid record on women's issues. He consistently supported abortion rights, rare for a Republican and risky in socially conservative Pennsylvania. He was out front on issues surrounding family and medical leave, the Women's Health Initiative, the Missing Children's Act and more.

Still, the game was on and it would become a war.

A SHORT ASIDE

During campaigns, especially ones closely contested, journalists know the importance of talking daily with key campaign staffers or advisors. You take a campaign's temperature by paying attention to things like tone of voice, mood, sense of urgency or hints of desperation.

Yeakel's people were accessible and easy to talk with. Specter's folks were more guarded, no doubt on automatic pilot, reset from experience in past campaigns.

But every Friday, while working on weekly wrap-up pieces, I'd get a call from a former Specter top aide (they are legion; Arlen went through staff like Sherman through Georgia) who mastered a perfect imitation of Specter's well-known, Kansas drawl.

This former aide (I protect sources) would purposely mispronounce Yeakel's name as "Yee-kill" and begin each call saying, "Ah, John? This is Ahlen Specter. Ah, now, John, as you know, Ms. Yeekill did not have a good week. I, on the other hand, had another fantastic week…"

At this point, the call devolved into various slurs and assertions that served no purpose other than Friday afternoon insider entertainment.

Perhaps you see this coming. On one especially busy Friday, I answer the phone at my desk in the Capitol Newsroom and hear, "Ah, John? This is Ahlen Specter." Having a bad day and heading toward deadline, I snapped, "Look, I don't have time for this shit today."

This was met with a drawn out, "Ex-Cuse me?" Because, of course, it WAS Arlen Specter, and I faced the choice of saying, "Oh, I'm sorry, I thought it was so-and-so who does a perfect imitation of your irritating voice," or simply saying, "Excuse me, Senator, I didn't hear you correctly."

I, of course, opted for the latter. A journalist should never give up a source.

TWO TV ADS

With the race close near the end of October, Yeakel went after Specter on multiple fronts since the Hill thing was in cement from the start. Yeakel tied Specter to a bad economy, a floundering President Bush and stressed it was time for a change. Specter, a twelve-year incumbent, had to go.

Specter, meanwhile, hammered Yeakel, gathered string and waited.

At the end of the campaign, with both sides putting up hard-hitting ads, this (in retrospect, with overdone clichéd sports analogy of which I am not proud) is the top of one of the stories I filed for the *Daily News*:

> *The gloves are off.*
>
> *Pennsylvania's Senate fight, near even and headed into the last round, has contenders Arlen Specter and Lynn Yeakel swinging from their heels with bare-knuckle TV ads designed to deliver a knock-out punch.*
>
> *Yeakel's ads say Specter is a scary, tired old pol who caused the bad economy. Specter's ads say Yeakel's a ditz.*
>
> *Both sides are looking to cut to the core and create or reinforce stereotypes about politicians new and old.*
>
> *A Yeakel ad features a spooky-sounding howling wind and fluttering, transparent curtains over unflattering black and white photos of Specter. Then some shots of Specter with Bush. And announcer's voice says this:*
>
> *"In the end, he's done everything he can to avoid the main issue. That Pennsylvanians are worse off today than they were 12 years ago. Instead, he is trying to confuse the record. He's run one of the most negative campaigns in the state's history. And now Arlen Specter wants six more years. But*

George Bush and Arlen Specter had their chance and we paid the price. Unemployment. Inadequate health care. Neglect of our cities. Twelve years is enough."

The ad, like most political ads, stretches the truth. *Specter's campaign was no more negative than most. But the ad reminded people, especially women, he's a scary guy: just like his name, a specter.*

For Yeakel, it's Specter's ad that's really scary.

It questions her capacity to serve in the Senate. It suggests she's too new, too raw, not ready. And it hits her with the most effective weapon that can be used against any politician, her own words.

It shows Yeakel in a series of broadcast news clips that made her look like an amateur. Here's the audio that went with it:

"Narrator: When Lynn Yeakel stood in front of a closed store in Erie and blamed its closing on Arlen Specter, a reporter told her it was closed before Specter was a senator.

Yeakel: (on news video) `Oh, well, then my information is bad.'

Narrator: Then she accused Arlen Specter of being a waffler. When asked to cite an example, she said…

Yeakel: (on news video) `I think…let's see. Hang on a minute…let me think about that…'

Narrator: If she can't get her facts straight now, what's she going to do in Washington?'"

—Philadelphia Daily News, *October 1992*

It was, as they say, a killer spot. It showed Yeakel ill-informed at best, totally lost at worst. It probably decided the election. Specter won by a little more than two percentage points.

Ironically, years later, a TV ad in another campaign would use Specter's own words. It also would be a killer spot and decide another election.

CASEY AT THE BAT

Governor Casey, meanwhile, was having an interesting '92 marked by his own aggressiveness on the issue of life, his opposition to the hot new national Democrat, Arkansas Governor Clinton, his pushing a comprehensive health-insurance plan for children and ongoing rumors that his health was failing fast.

In February, in an example of what some would call in-your-face tabloid journalism and others would (and did) call going too far, I wrote a piece comparing Casey to then-New Jersey governor Jim Florio.

Both signed massive tax increases and each watched his popularity plummet. *U.S. News & World Report* named both states' actions among the "10 worst economic moves" of 1991.

But Florio was fighting back while Casey seemed flat on his back.

Both had sports backgrounds: Florio was a boxer; Casey played basketball at Holy Cross (on the same team as future NBA hall of famer Bob Cousy).

But Florio, fifty-four, and Casey, sixty, offered obvious contrasts. Florio was bold and aggressive; Casey cautious and deliberate. Florio energetically tried to steal Philadelphia's NBA and NHL teams; Casey half-heartedly tried to steal Lee Iacocca for a Senate seat.

Part of the reason for different approaches was that Florio faced reelection the following year whereas Casey could not run again because of Pennsylvania's two-term limit.

But another part of the reason, as the piece made clear, was personal style and appearance.

Florio was "pugnacious, hyperactive;" Casey was "reserved, dull." Florio looked fit, in fighting trim; Casey looked ill. If it all wasn't clear enough to readers, our graphics folk ran side-by-side pencil drawings of the two. Florio looked like a statesman. Casey looked like a stick man.

The piece evoked immediate outrage from Casey's corner.

The governor's press secretary, Vince Carocci, wrote a letter to the editor to remind readers I had worked for the person Casey beat in '86 and saying that might explain "the perspective Mr. Baer brings when he writes about Gov. Casey."

Hey, it was nice he called me "Mr."

Casey's chief of staff, James Brown (not the "I feel good" James Brown, a different one), wrote me a letter calling the piece "vicious and despicable."

(He later would serve as chief of staff to Casey's son, Senator Bob Casey Jr.)

And the governor's general counsel, Jim Haggerty, sent me a handwritten note that said, in its entirety, "You ought to be ashamed of yourself!"

In retrospect, they knew something I did not, which was that Casey was sicker than rumors suggested. I'm not saying the piece wasn't rough. But their anger reflected loyalty and affection to and for their boss.

I eventually reconciled with all three and even with Casey. More on that later. But first, a look at the national news Casey made because of Clinton.

CASEY AND CLINTON

Casey didn't like Clinton because of Clinton's stance on abortion and because of alleged infidelities that surfaced during his run for the White House.

How averse was Casey to Clinton?

In April 1992, just before Pennsylvania's Primary, Casey called the Democratic front-runner the wrong candidate for the party and urged uncommitted convention delegates to remain neutral.

He noted low-voter turnout in a number of states and told the *New York Times*, "The primary process is not producing someone who has a good crack at winning in November...We've got a tiny minority of Democrats voting for Bill Clinton and he's winning every race without generating any sparks, any enthusiasm, any momentum...people have a tremendous unease about him. He's got a tiny, fly speck of support."

Casey probably should have added, "In the Casey household."

Things got worse at the convention in New York.

Democrats were pumped about the prospect of winning the presidency, and none were more fired up than Pennsylvania Democrats. They were enthused about Yeakel's candidacy. They still were reveling in Wofford's win. And there was even some buzz that Clinton could tap Wofford as a running mate for geographic and age balance.

(When Clinton picked Tennessee's Al Gore, the *Daily News* front-page headline read "Double Bubba.")

Then came Casey.

Never known as the life of the party, Casey cast a pall over the state delegation by refusing to endorse Clinton and insisting on addressing the convention on abortion. He called it "the most important issue of our time." He said the Democratic platform supporting abortion rights was "far left, radical and extreme."

State delegates, no doubt because of Casey, were seated in the nose-bleed section of Madison Square Garden. Casey sat there stone-faced and told reporters, "This convention has suspended the First Amendment."

To say he didn't have 100 percent support of his delegation would be putting it mildly. Many were embarrassed and annoyed. Some were outraged. Several spoke publicly.

Philadelphia state senator (now congresswoman) Allyson Schwartz, a member of the platform committee, called Casey out of touch and said he was pushing "an individual opinion that does not represent the delegates or the party."

And a leading pro-choice state lawmaker, Representative Karen Ritter from Allentown, got national attention by producing and selling "Pope Casey" buttons depicting Casey dressed as a Pope (which actually was pretty funny and somewhat believable).

The buttons went on sale pre-convention for six dollars. In New York they were selling for ten dollars. "I'll bet they go for twenty dollars by week's end," Ritter said.

As I recall, they did.

Casey also got a message from convention chairwoman Governor Ann Richards of Texas. After asking for podium time two weeks before the convention started, he also asked Richards for floor time opening night.

Richards affirmed the rejection of Casey's requests in her opening address: "My name is Anne Richards. I'm pro-choice and I vote."

The convention erupted in hoots and cheers.

All this was great fun to cover. Casey sat in his convention seat sporting a button that read, "I'm a pro-life Democrat. I want my party back." He even got, as mentioned earlier, ten delegate votes for president from pro-life members of the Minnesota delegation.

But in the end, the Clinton team reached out. They had Gore call Casey. Nothing really changed. But Casey cooled down to the point that at least he didn't grab the microphone during the call of states and try to shout down his party.

Instead, he allowed his state chairman to cast Pennsylvania's votes for Clinton. Casey aides called it "tantamount" to an endorsement.

But Casey was always coy after November about whether he personally voted for Clinton. Knowing Casey's stubborn nature (and stand on principle), I'm thinking he did not.

CASEY CARRIES ON

Because Casey never gave up on anything, he didn't give up on his anti-abortion crusade.

In October 1992, he went back to New York, invited by the *Village Voice*, to speak at Cooper Union. He was shouted off the stage by protestors chanting, "Casey, sexist, anti-gay. Governor Casey, go away." But later that month, he delivered the speech at the forty-second annual dinner of the Alfred E. Smith Memorial Foundation, also in New York.

In November 1992, Casey got what would be one of his defining achievements: passage of his Children's Health Insurance Program (CHIP) to ensure all kids in Pennsylvania would have health insurance. It covered, for the first time, children whose families didn't make enough to buy insurance but made too much to qualify for medical assistance. It was a major victory, and it became the national model for child health care.

Didn't mean Casey was done with abortion.

He spoke at Notre Dame, Princeton, Boston College, Yale and elsewhere. He went on all the TV networks, *Larry King Live* and anywhere he could get air time. In May 1993, he spoke at the National Press Club and created buzz about using the anti-abortion fight as the core of a bid for president in 1996.

I wrote a column, one of many Casey and his team didn't like. It appeared in the form of a memo from me to the governor. Here's an excerpt.

TO: BOB CASEY
RE: ABORTION AND THE PRESIDENCY

> *So, you're at it again.*
>
> *You made a speech to the National Press Club.*
>
> *It was pretty much a revisitation of your oft-stated anti-abortion views, but it brings you renewed political attention by raising the prospect you'll run for president in 1996.*
>
> *Governor, permit me.*
>
> *Don't.*
>
> *Such a run would be—how can I put this?—a joke. Worse, preparing for it would abandon your responsibility to a state that twice elected you to serve it.*
>
> *Look around. Pennsylvania needs active leadership on issues like school funding, worker's compensation and court reform.*
>
> *Parts of Pennsylvania, like the steel valley in the west and your home coal-region in the northeast, still suffer from never replaced job losses.*
>
> *Cities, especially Philadelphia, need attention and assistance.*
>
> *For the first time in a decade—and for the only time during your tenure—you've got a state House and Senate of your own party. Use them. Use the rest of your term to serve Pennsylvania on as many fronts as you can.*
>
> *Pennsylvania is not being served by a time-consuming personal crusade on a single issue, any single issue that jets you around the country to talk shows and speaking engagements.*

Twenty-five Years of Keystone Reporting

Despite what you think, you were not elected in 1986 and reelected in 1990 because of your stance on abortion. I know you've got some cooked-up numbers to suggest you were. You weren't.

You never ran as an anti-abortion candidate. There were no TV commercials on the issue. None taking credit for the 1989 Abortion Control Act. No pledges to take up a national crusade.

In fact, your second inaugural speech, a six-page, single-spaced document, does not mention abortion in a long list of items you promised to address in your second term.

I've reported on our administration since you took office in 1987. You and I have had our differences. I know you think, or once did, they stem from the fact I worked for the person you beat to win the governorship in 1986.

The fact is I also covered you for another newspaper prior to that race; and—I hope you're sitting down—have long believed you to be a cut above the normal slabs of hack politicians our state sees fit to elect.

Which isn't to say you've not made bonehead moves: seeking reelection in 1990 as "the rising star" while the economy headed into the toilet; taking a fat pay raise in 1991 while laying off state workers; insisting on speaking at the 1992 Democratic convention even after it was clear you were as welcome as Jeffrey Dahmer at a day-care center.

Nonetheless, I harbor this thread of regard.

For three reasons: your fine family, many of whom I know and respect; your political survival in a state known for steamroller politics; and your occasional willingness to pitch political gain for things you believe in.

…Many call this trait stupidity. Others say it's dark-Irish stubbornness. A few, mostly those you pay, call it courage.

Whatever it is, call on it now. You've done what you can on abortion.

—Philadelphia Daily News, *May 13, 1993*

The very next month, in June 1993, Casey turned over the power of his office to Lieutenant Governor Mark Singel and underwent a rare double-organ transplant at the University of Pittsburgh Medical Center.

Casey received a new heart and liver in an effort to replace his damaged organs and reverse his amyloidosis. Afterward, his doctor said Casey's heart was "as hard as a telephone."

On the same day, on the other side of the state, another politician also went under the knife. Can you guess? Arlen Specter! He had a brain tumor removed at the University of Pennsylvania Hospital in Philadelphia.

Some suggested Specter couldn't stand Casey getting all the attention.

Casey's full recuperation took six months. He returned to office in December 1993 and pledged to serve out his term and work hard. He, of course, would also continue to be active on the issue of abortion.

And by now, no matter what one thought of him or his tax hike or his salary hike or his abortion stance, there was widespread feeling the guy was as tough and determined as they come and, out of that, a growing respect.

The legislature gave him a going-away present by passing an organ-donor bill Casey had pushed for designed to increase availability of organs for patients in life-threatening situations.

When Casey signed it into law in December 1994, he was surrounded by other transplant recipients.

"As you might imagine," he said, "this legislation means a great deal to me."

LUNCH WITH CASEY

Two years after Casey left office, I ate lunch with him in a hotel in his hometown of Scranton. It was January 9, 1997, his sixty-fifth birthday. It was the first time I'd seen him since he was governor.

And almost every time I saw him when he was governor, it was under press/public figure conditions marked by confrontational questions about taxes, welfare cuts, abortion and his health, which is to say that almost everything Bob Casey said to me during the previous decade came in stern words and clipped phrases delivered under a furrowed brow.

At lunch, he actually looked pretty good. But he was his usual self, meaning not all that warm and snuggly.

The luncheon approached an unnatural act for three reasons: I worked for the guy who ran against him in a race that got personal (as in, Casey was a fat-cat lawyer has-been who'd take the state to hell in a handbasket); I'd written about him in less than promotional terms; and by every rule of reason and science, given all he'd been through, he shouldn't be dining with anyone other than maybe St. Peter.

We talked about his eight grown children and twenty-three grandchildren, with three more on the way. We talked about pasta fagiole (only because it was on the menu) or, as he called it, "bean soup," as in, "I like bean soup." And we talked about him returning to the practice of law because he wanted

to be active and because he needed, as he said, "to pay the butcher, the baker, the candlestick maker."

I don't know what to tell you. That's what he said.

When I wrote about the luncheon, I mentioned Casey's devotion to family, uncompromising pro-life stand and his unbreakable will. I wrote that he was no ordinary pol and no ordinary man. Here's how the column ended.

> *We talk more. At length, actually. A range of things political, a few personal. And when it's over, I leave with this: a lifetime of work and campaigns, wins and losses, illness and recovery and more illness, and at age 65, Bob Casey is still not done.*
>
> *He's still pushing. Still at the table. Still looking ahead. And ya gotta admire that. And I do. The guy's a rock. And somewhere along the line he became a piece of Pennsylvania history. He cheated death, grew larger than life and remains "the real" Bob Casey.*
>
> —Philadelphia Daily News, *January 1997*

AND AT THE END

Casey died in 2000. His funeral was like something out of a political novel: *All the King's Men* (1946) by Robert Penn Warren, or *The Last Hurrah* (1956) by Edwin O'Connor.

It was old-style politics on a grand scale, as observed by the gently-referred-to Scranton Irish Mafia.

Five governors, five bishops, bagpipers and one thousand mourners packed the old, ornate St. Peter's Cathedral in downtown Scranton.

Anyone who was anyone in Pennsylvania politics was there. Many had memories or stories to share.

Republican Barbara Hafer, who lost to Casey in 1990 after calling him a "red-neck Irishman," recalled how she reluctantly phoned Casey that election night to concede. She said he (who lost three bids for governor) laughed and told her, "Don't worry about it; the first time is the hardest."

National Democratic Chairman, former Philly mayor and future governor Rendell (who also lost to Casey in the '86 Democratic primary for governor) called Casey "the public servant who had the greatest impact on this state in the last century."

And the ever-present you-know-who (yep, Arlen) recalled going under the knife the same day in '93 as Casey's transplants and noted he and Casey were "both sort of strangers in our own parties"—he a pro-choice Republican, Casey a pro-life Democrat.

Casey became a political legend, and his legacy would live on through his family, especially his oldest son, Bob Jr., who, like his father, went to Scranton Prep and Holy Cross, became a lawyer, got elected state auditor general and ran for governor and lost in a Democratic primary (we'll get to that).

The younger Casey resembles his father in many ways, including in his pro-life position. But as anyone who knows the family will tell you, in manner and personality, he more resembles his mother, Ellen Casey, than his often-fiery dad. He's currently a U.S. senator. There are those who still think he'll one day run for governor again.

CHAPTER 4
THE RIDGE YEARS

A t the start of 1994, Pennsylvania was popping with politics.
There was an open-seat race for governor with a pack of candidates in both parties representing more variety than the state ever saw or likely will see again.

Ten men and two women, seven Republicans and five Democrats vied to succeed Governor Casey.

It was quite a mix: a sixty-three-year-old, a thirty-four-year-old, an African American, a Jew, an Irishman, an Italian and more. They came from cities, suburbs, the sticks and the coal regions. They were from Philadelphia, Pittsburgh, Erie and Scranton. They were in office and out of office. Some had years of government experience, others none at all.

Why more Republicans than Democrats? Because of Pennsylvania's "cycle" of voters switching the party in the governor's office every eight years, no matter what.

It's been that way since 1946: eight years of a Democrat, eight years of a Republican, eight years of a Democrat and so on. And it stretches back to before governors could serve two terms starting in 1974.

Some dismiss it, especially those running after their party held the governorship for eight years, and there are those who say it's a fluke.

I'm not among them.

Two of the state's most prominent political scientists, G. Terry Madonna, of Franklin and Marshall College, and Michael Young, a former Penn State professor, wrote about it in an op-ed piece in 2009. Here's part of what they wrote:

The probability is less that 0.000141% that this string of gubernatorial elections could have happened simply by coincidence. Put differently, the odds are more than 5,000-to-1 against getting such an alternating string of election results, unless something meaningful has been occurring to produce the pattern. This is solid and persuasive statistical evidence.

Maybe the "something meaningful" is that voters get sick of the same governor after eight years. Not that it's the governor's fault (well, sometimes it is), but the state is so partisan, maybe its most visible political figure wears thin.

Or maybe voters have some sense of fairness that plays out as "you had your chance; let's give the other side a shot."

Whatever the reason, the cycle probably contributes to the state's lack of progressive policies. It's pulled one way for eight years, say, in spending increases for education and then is pulled another way for eight years, say in cuts to education.

As a result, the state's stuck in a rut as voters use parties and process to play ongoing games of Swap-a-Guv.

So Republicans in '94, after eight years of Democratic rule, were more excited about their primary than Democrats. Virtually everyone close to the process believed one of the GOP candidates would be the next governor.

Plus, it was an off-year election with a Democrat in the White House. Voters angry at Washington (and when are they not?) could express that anger by voting for state candidates in the party not in the White House.

And there *was* the nearly $3 billion tax increase, the largest in state history, signed in '91 by Democratic governor Casey.

The GOP in Pennsylvania was Glad-O-Plenty in '94.

THE '94 PRIMARY

Early polling favored Casey's lieutenant governor, Mark Singel, of Johnstown, and Republican state attorney general Ernie Preate Jr., of Scranton.

Neither would win his party's endorsement.

The GOP field had serious contenders and one not-so-serious. There was Sam Katz, Mike Fisher, Tom Ridge, Preate and John F. Perry.

Perry was a Clinton County pro-life doctor who ran for U.S. Senate in 1992 as a Libertarian. He finished last in '94. He didn't carry Clinton County.

Fisher was a state senator who'd run statewide (for lieutenant governor in 1986); Preate was attorney general; Ridge a veteran congressman and Katz a wealthy Philly businessman who built a company that helped governments and school districts finance public projects.

AN ASIDE: A LITTLE PERSONAL HUMILIATION

When Katz first was thinking of running for governor, I talked with him during an annual Pennsylvania political event in New York City, Pennsylvania Society Weekend.

It's a gathering of powerbrokers and those who want to be, elected officials and those who want to be, for a string of parties, dinners, fundraisers, receptions and forums, anchored by a Saturday night black-tie banquet at the Waldorf-Astoria Hotel.

This happens every December; the "society" was founded in 1899.

The Waldorf opened in 1893. And the "society" was wealthy business guys living in New York but from Pennsylvania.

Speakers at the banquet have included Andrew Carnegie, Henry Ford, Dwight Eisenhower, Andrew Wyeth, Joe Paterno, Bill Cosby and Fred (Mr.) Rogers.

You get the idea.

Anyway, after such weekends, which can tax one's capacity for writing cogently, I mentioned Katz's intention to run for governor in a piece I wrote on the train on the way home.

But an apparent loss of brain cells forced me to write that Harold Katz, then-owner of the Philadelphia 76ers, was considering a run for governor.

This is the sort of thing that requires, as they say, a prominently-displayed correction; which, of course, was done.

But Sam Katz, because he has a sense of humor, wasn't through with me.

The 76ers drafted Shawn Bradley from Brigham Young University, a 7'6" shot blocker who instantly became the talk of Philadelphia. Team marketing people must have loved the coincidental numbers involved.

Katz (Sam, not Harold) sent me a Polaroid photo of Bradley working out on a chest-strengthening exercise machine and had Bradley pen me a hand-written note and sign it.

The note read: "John: Vote for Sam, not Harold."

Katz was too "city" for the rural GOP base. He finished first in Philadelphia, but third in the field of five.

Fisher wasn't as well known as he thought and was from Democratic Allegheny County in a primary only open to Republicans (Pennsylvania has "closed" primaries). He finished fourth of five.

Preate, twice elected attorney general, was a proud Italian, a gregarious populist and a pro-life conservative who'd served in the marines. He had great support among cops, ethnic groups and veterans. But he had a problem. He spent much of 1993 under a cloud that descended upon him after the Pennsylvania Crime Commission accused him of making deals with video poker bosses in Northeastern Pennsylvania when he was district attorney there.

Preate finished second. We'd hear more about him the following year.

Ridge was the candidate built in a GOP test lab: tall, sturdy, friendly, even if often robotic. He came fully assembled with credentials tailor-made to win statewide: born into public housing, academic scholarship to Harvard, drafted out of law school to Vietnam, served as a decorated infantry sergeant.

After his stint, he returned to law school (Dickinson in Carlisle), then practiced law in Erie, served as a county prosecutor and was elected to Congress in 1982 in a Democratic district, a seat he held until he was governor.

He started out, as I wrote early in the campaign, "a guy nobody ever heard of from a city nobody's ever seen." But he worked hard, raised money and used my line in his first TV ad as he posed in a bomber jacket by a frozen Lake Erie.

(His media advisor was Stuart Stevens, a media advisor to Mitt Romney in 2012.)

Ridge's slogan was "He can change Pennsylvania, honestly." He beat Preate by 57,303 votes out of almost a million cast.

The Democratic field included Phil Valenti, of Delaware County, a self-described "associate" of frequent presidential candidate Lyndon LaRouche, and Chuck Volpe, a thirty-four-year-old millionaire from Scranton who inherited an insurance company. Some in the media (okay, maybe it was just me) referred to the two as "The Killer V's." Their campaigns died a quiet death.

There were also familiar names and faces: former House Speaker Bob O'Donnell from Philadelphia, Catherine Baker Knoll from Pittsburgh, state representative Dwight Evans from Philadelphia, Lynn Yeakel from the '92 Senate race and Lieutenant Governor Singel.

They were a hopeful but quirky bunch, running against the "cycle."

O'Donnell, smart, witty, familiar with all aspects of government and politics, tried to reform the House and cut its perks so, naturally, he was doomed.

Lynn Yeakel announces for the 1994 governor's race: a bad idea. *Andrea Mihalik/*Philadelphia Daily News.

Yeakel found out the "Year of the Woman" was over. She finished fourth.

Knoll, twice-elected state treasurer, was wildly popular among long-time party types, especially in her Western Pennsylvania base. But she was never known as practiced or even marginally able in the art of big-time politics.

Lovely woman, just not a prime-time performer. In '94, at age sixty-three, she finished what had to be a disappointing third in the Democratic primary.

Dwight Evans was a surprise. Here was a thirty-nine-year-old African American running for governor in the state James Carville called "Alabama without black people."

But Evans ran statewide before, for lieutenant governor in '86, and was active in the state House, where he chaired the powerful Appropriations Committee.

Philadelphia gave him more than half his statewide total.

He finished second in the fat field of seven.

Singel, only forty, already was twice elected to the state Senate, twice elected lieutenant governor and filled in as "acting governor" during Governor Casey's six-month recovery from transplants.

His slogan was "Ready Right Now."

He didn't come without baggage. Despite serving as acting governor, his own party declined to endorse him. Casey didn't endorse him. They had a parting of the ways over abortion. But Democratic voters gave Singel the nod, and he was off to fight the "guy nobody ever heard of."

Voter turnout in the '94 primary, as mentioned in chapter 1, was 23 percent; this in an open-seat election with a variety of candidates who spent $24.2 million to generate enthusiasm.

But there was none. Democrats were disappointed that President Clinton's popularity plummeted in '94, and Republicans were disheartened that their party was being dragged off to the hard right.

Ridge and Singel won not because they were fresh new faces of hope and reform. They won because they spent more money than anyone else in a campaign with low interest and dismal turnout.

THE '94 GENERAL ELECTION

To put this race in context and show how far Pennsylvania politics fell from its dizzying heights during '91 and '92, consider Singel and Ridge: a pair of white guys in their forties from a pair of, literally (according to state code designation), third-class cities.

They spent the bulk of their careers in political dead zones: Singel as lieutenant governor (five states don't even HAVE lieutenant governors); Ridge as back-bench minority party congressman.

Such jobs are not exactly breeding grounds of creative thought or fountains of unique political expression. And, with the exception of Singel filling in for Casey, require no actual responsibility.

They were (and are) different people.

I remember being with Singel at a campaign stop at a retirement center outside Pittsburgh where he went up to seniors trying to eat lunch and yelled, "Singel, you know, like not married!"

I tried to stay out of sight.

Once, while I was waiting to interview him in his Capitol office, he walked in and addressed his campaign aide, Beth Shipp, enthusiastically, as "Bethmeister!"

She responded, with equal enthusiasm, "Markmobile!"

The chances of Ridge and/or any of his staff ever having such an exchange were the same as the chances of Ridge walking across Lake Erie in summer.

Ridge was the guy who wanted to sit in your living room and sell you term life insurance. A *Daily News* colleague, Dan Geringer, after interviewing Ridge, once said he kept watching Ridge, "waiting for the batteries to fall out of his forehead."

I had a pretty good sense Ridge would win the race, not only because of the "cycle," but also because spending time with candidates gives one a feel for how they'll come across to voters.

Campaigns strip candidates to their elemental selves. Flaws surface; assets shine. Interviews with Ridge and Singel—one long before the campaign, the other on a key day for Singel—convinced me that Ridge, barring unforeseens, would be the next governor.

The interview with Ridge was a long, poolside chat at the Houston Airport Marriott Hotel during the August 1992 Republican convention.

It was friendly and relaxed because what better way to enjoy a sweltering Texas day than with the overhead roar of airline traffic and the wafting scent of jet fuel?

Ridge talked about running for governor, and what struck me was his tone and attitude. For even far removed from any contest, he was serious and reserved and spoke in measured phrases, sometimes knitting his brow in concentration, picking words carefully as if on camera.

Good, I thought, Pennsylvania will like this. Steady. Calm. No nonsense, a younger, healthier Bob Casey, without an abortion crusade.

I interviewed Singel on June 14, 1993, the day of Casey's transplants. We were alone in the foyer of the state Senate chambers. (As lieutenant governor, he presided over the Senate.)

Remember, this was a critical time. The surgery was rare, and many believed Casey would not survive or, if he did, not return to office.

I asked Singel what he felt when he got a call at four that morning telling him a donor was found for Casey and that he, Singel, was "acting governor" of the state.

He told me he got up with his wife, Jackie, and sat at the kitchen table at the lieutenant governor's residence at Fort Indiantown Gap. He said they "just talked." Then he said, "It was a real Maxwell House moment."

I'm sure I cringed even as I took notes because I know I was thinking, not good; Pennsylvania won't like this. Nothing about Casey. Only about him and his wife and coffee. Too flip. Too commercial. Too made-for-TV.

And I understood then as I understand now, moments do not reveal all of a person. But they offer hints and insight. And those moments provided valuable info on the essential natures of Ridge and Singel.

AN ASIDE: A STORY ABOUT A SUPREME MESS

In case you doubt that every aspect of Pennsylvania government and politics includes the kinds of stories that make any sensate person shake his or her head, here's one about the Pennsylvania Supreme Court.

During the late 1980s and into the 1990s, the court was a supreme mess. There were internal spats among justices and alleged racial slurs directed at Chief Justice Robert N.C. Nix Jr., who was black. There was arrogant, non-transparency regarding the court's use of public money (Justice Stephen Zappala told the state Senate "no," he'd really rather not say how the court spent expenses).

It was, in short, an isolated, insular court.

Many in the political community blamed this on the fact Pennsylvania was (and is) among only a handful of states electing judges at all levels even though voters, especially statewide, know nothing about those running for various benches.

But the particular mess I'm referring to centered on one justice, Rolf Larsen.

He, in the middle of the '94 race for governor, earned the distinction of becoming the first justice impeached since a generation before the Civil War.

Larsen, from Pittsburgh, ran up an impressive list of allegations of improper, illegal and apparently insane behavior, all while enjoying the relative high-life judicial pay and perks provided.

His business card was made of supple, gold-embossed black leather. Don't believe it? Check with me, I still have one.

He was accused of trying to influence cases and earmarking cases involving attorney friends and political contributors for favorable treatment.

He had accused fellow justices of wrongdoing, but then he was convicted of illegally obtaining prescription tranquilizers and antidepressants by having his doctor write scripts using the names of his court employees, including secretaries and a law clerk.

In addition, there was testimony from one of Larsen's secretaries that she shopped for porno mags, jockstraps and cigars for Larsen. I and others found it easy to conjure scenes in Larsen's chambers involving his simultaneous use of all three.

Perhaps most famously, Larsen alleged that the perk-protecting Zappala, one of many on the court with whom he feuded, tried to run him down in a Mercedes-Benz outside the Four Seasons Hotel in Philly (where justices stay because they can) with then-powerful Philadelphia state senator Vince Fumo a passenger in the car.

Turned out Fumo was driving. And Fumo denied attempting to run Larsen down, adding that if he intended to flatten the justice, the justice would have been flat.

Can you see why I love this state?

In May '94, the state House voted articles of impeachment on a long list of charges including the drug stuff, improperly assisting friends and

Rolf Larsen, a state Supreme Court justice who was impeached in 1994. Philadelphia Inquirer.

contributors before his court, engaging in improper discussions outside of court with lawyers and a trial judge and lying to a grand jury.

The vote was 199–0.

In June '94, Larsen was removed from the seven-member court following his conviction in Allegheny County on the drug charges.

And in October, the state Senate convicted Larsen by a vote of 44–5, ending his twenty years on the bench, first as an Allegheny County judge and, since 1978, as a Supreme Court justice. There is no appeal of a Senate conviction.

MY OWN FUN WITH THE LARSEN CASE

The case is close to my heart because it involved a fun assignment. During Larsen's trial, the Senate (and Larsen's lawyer) wanted to call the Mercedes-driving Fumo and issued a subpoena since Fumo was out of the state.

We at the *Daily News* got wind of his whereabouts, and—because these were times when newspapers still had resources—I was dispatched to find him.

Fumo, we learned, was with friends on the chic resort island of Martha's Vineyard off the coast of Massachusetts. I flew to Boston, grabbed a puddle-jumper to the Vineyard and undertook my search.

The thinking was what fun it would be if a lowly journalist was able to find the big-shot senator that the powers that be in Pennsylvania could not.

When I arrived at the Vineyard's tiny airport and sought a rental car, I was told there were none because President Clinton and family were expected and tourists and others flocked to the place for the chance to hang with Bill.

Having little choice, I plopped down an American Express card and told the person at the rental counter, "You don't understand, I need a vehicle and I don't care what it costs." Those were the days.

This tactic, as is often the case, worked. I got a Lincoln Continental and soon was squeezing down the narrow streets of Edgartown.

I began my search by approaching what I took for locals and asking, "Excuse me, have you seen an affluent, middle-aged powerful-looking white man?"

This seemed not to work. I narrowed my search by questioning anyone in a Phillies cap or t-shirt. But even when I offered the name "Fumo," I couldn't get a nibble.

Luckily, I was not sent without backup. My *Daily News* colleague, Cynthia Burton (now a member of the *Philadelphia Inquirer* editorial board), was back in Philly working the phones.

She not only found exactly who Fumo was with—a lobbyist and a top city official—but she worked some real estate contacts and came up with an address.

She was, and is, among the best.

I went to the house, a gorgeous old sea captain's home on Water Street, and knocked on the door. A young woman answered. I asked if Senator Fumo was in. She said, no, he had just gone to the south beach with a few other folks.

Back into the Continental and on to the beach. I walked and walked but couldn't find Fumo.

It was then I started to think my piece for the next day's newspaper would actually be funnier if I didn't find him. And it was. Our expert graphics folks—using multiple tiny headshots of Fumo and a map with each head over his favorite east coast hangouts in Florida, New Jersey and, of course, the Vineyard—came up with a "Where's Vince?" theme ala the kids book *Where's Waldo?*

It was one of those days when it was more fun to be a journalist than just about anything else.

BACK TO THE '94 RACE FOR GOVERNOR

By early October, the race was tight because few voters were engaged, because Singel still enjoyed goodwill from service under Casey and because there were (and are) more registered Democrats in the state than Republicans.

Issues were breaking down to the economy and crime, the latter due to an uptick in the crime rate, especially juvenile crime. Ridge played to the issue on grounds he'd been an Erie County prosecutor. Singel cited his experience as head of the state Board of Pardons, a duty of the lieutenant governor. They traded barbs in TV ads.

Singel met with a group of prisoners serving life and suggested a more lenient approach to pardons. Ridge hit him for it. Ridge was only a "part-time" assistant Erie district attorney. Singel hit him with it. Each tried to paint the other "soft" on crime.

Then the game changed.

Late on Friday, October 7, came news that a forty-one-year-old former Philadelphian, Reginald McFadden, was under arrest in New York state, charged with the kidnap and rape of a fifty-five-year-old woman and suspected in the stabbing and strangulation killing of a seventy-eight-year-old woman.

McFadden was serving life in Pennsylvania for the 1969 murder of a sixty-year-old Philadelphia woman until his release in July 1992.

He was released on the recommendation of the Board of Pardons.

The board chairman was you-know-who, and you-know-who voted to let McFadden out.

Here are excerpts from what I wrote about the case, under the headline "In a Flash, a Race Transformed."

For Singel, this could not have come at a worse time. For Ridge, it is nothing short of a gift from the political gods.

Consider.

State pollsters tell us crime is second among voters' concerns only to unemployment. More, crime is the only issue in Pennsylvania showing a steep and steady increase of concern over the last four years.

The race for governor, which started with all the intensity of a late-afternoon nap, just became embroiled over crime...

Singel let this guy out; Ridge says he wouldn't have. Even before the case, Ridge said, "Life means life." Worse, Singel before the case, said,

"I defend all my actions" on the pardons board, "I've done the right thing consistently."

By late Friday, he was calling the McFadden vote, "a mistake that I deeply regret."

Facts about pardons board actions will be lost in the easy target this case presents. When, for example, Singel calls the state board among the toughest of its kind in the nation, he's right.

There are 2,614 lifers in Pennsylvania. In Singel's eight years as chairman, the board recommended only 135 commutations to Gov. Casey. Moreover, the board can let no one out. Only the governor can. Again, a fact that will pale in the blaze of campaign spotlights.

Also, Casey was tougher than the board. McFadden, after 24 years in jail, was one of just 26 Casey commutations, less than 1 percent of those serving life terms.

Casey even tried to help Singel. He said in a statement, "The power to commute a life sentence in Pennsylvania rests with the governor. I made the decision in this case...I take full responsibility."

Won't matter. Casey's not on the ballot...On the very day the McFadden story broke, Ridge started a TV ad saying, "Tom Ridge put criminals in jail. Mark Singel voted to let them go."

—Philadelphia Daily News, *October 10, 1994*

Ridge took a lead in the polls although, even with the McFadden story, by the end of October there were still 20 percent of voters "undecided."

On Election Day, Ridge beat Singel by five percentage points.

THE OTHER RACE IN '94

Nationally, this was the year of "The Republican Revolution."

The GOP picked up fifty-four U.S. House seats to claim a majority for the first time in forty years, eight Senate seats and a dozen governorships, including George W. Bush in Texas and Ridge in Pennsylvania.

One of those Senate seats that got flipped was held, however briefly, by Harris Wofford, aka "Senator Surprise."

He faced a brash thirty-six-year-old, second-term congressman, Rick Santorum, who attracted national attention in "The Gang of Seven"—newcomer House members who helped uncover a financial scandal in which hundreds in Congress overdrew money from the House Bank.

It was Wofford, intellectual and liberal, vs. Santorum, ideological and conservative and strongly supported by the Christian right, the NRA and the state's many sportsmen's groups.

It was a campaign of clear choices at a time the nation was clearly choosing Republicans.

That Wofford originally was elected pushing reforms in health care, that he spent so much time in Washington working the issue and the fact Clinton's proposed health-care plan went down in flames, branded as big, liberal government, all worked against the incumbent.

I always believed Santorum too far right for Pennsylvania, a state known for electing moderates, but in '94, the GOP argument for less spending and less government sold everywhere, including the Keystone State.

I moderated a debate among Wofford, Santorum and some third-party candidates. Wofford was his usual thoughtful self, seeking to explain key policy points. Santorum was his usual aggressive self, seeking to rip Wofford from the Senate. And he did, carrying fifty-six of the state's sixty-seven counties in a year Republican turnout surged and Democratic turnout slipped.

Santorum would rise to number three in Republican Senate leadership before losing to the son of the late Governor Casey in 2006 and before becoming a contender for president.

RIDGE IN OFFICE

When Ridge took office in '95, he pushed the crime issue with a special session of the legislature.

Pennsylvania got about three dozen new laws, including a law to put three-time violent offenders away for life, a popular initiative in 1995: eleven other states passed the same thing.

Ridge got a Megan's Law to better ID registered sex offenders, mandatory sentencing, tougher juvenile-crime laws, a victims' advocate office and a law to speed implementation of the death penalty.

State prisons filled up, state corrections budgets ballooned and by the time Ridge was running for reelection in 1998, crime was down across the nation but not in Pennsylvania.

Both violent crime and the overall crime index dropped in the United States and in New York, Ohio, Texas, Wisconsin, Michigan and New Jersey (all under Republican governors), but increased in Pennsylvania.

There are those, I should note, who don't trust crime rates, who contend they're too easily manipulated by law enforcement agencies seeking to prove they've cracked down on crime or trying to pump up their budgets to fight crime.

The Ridge administration's response to questions about why Pennsylvania's rate was moving against the national grain was to suggest its policies would take time to show measurable impact.

Meanwhile, Ridge's first term was marked by a couple contrasts: a paint-by-numbers GOP style and an odd walk-back of a campaign pledge.

On governance, Republicans, after the "revolution," largely delivered on promises. Ridge and others such as New York's George Pataki, Ohio's George Voinovich, Texas' Bush, Wisconsin's Tommy Thompson and New Jersey's Christie Whitman cut taxes, passed anti-crime bills, cut welfare and launched education "reforms," such as charter schools.

As a result, and especially due to a strong national economy, most states saw poverty levels and unemployment rates drop and per capita income rise.

It was a good time to be an incumbent Republican.

As to the odd thing, candidate Ridge said he opposed giving lawmakers a pay raise. Yet, in his first year, he signed a bill hiking lawmakers' base pay 18 percent and, for the first time, adding annual cost-of-living increases.

The raise extended to Ridge, judges and cabinet members. The legislature passed the pay raise bill without debate and then, to circumvent a constitutional restriction against raising their own salaries while sitting in office, they assigned themselves "unvouchered expenses" so they could collect the dough right away.

It was a sleazy tactic they'd use again in 2005. They do this because they can.

Ridge's excuse? Said he didn't realize lawmakers hadn't had a raise in eight years.

One would think a candidate for governor speaking on an issue as publicly sensitive as legislative pay ought to know what he or she is talking about before making promises.

Just not in Pennsylvania.

AN ASIDE: ANOTHER MESS IN PENNSYLVANIA

On December 14, 1995, former state attorney general Ernie Preate Jr., who came in second to Ridge in the primary, stood half-crying in a federal courtroom in Harrisburg seeking leniency from a judge.

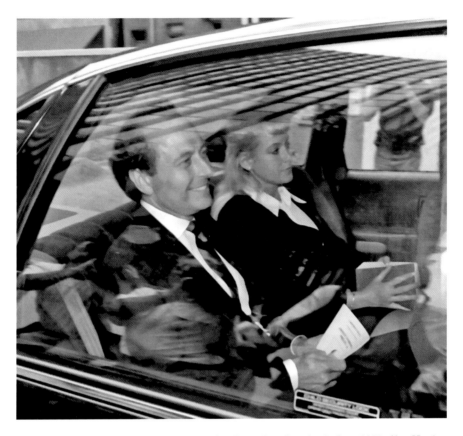

Ernie Preate and girlfriend Susan Baxter after Preate's guilty plea in June 1995. *Yong Kim/* Philadelphia Daily News.

It was the end of a saga showing again that no branch of Pennsylvania government is untainted.

Preate resigned in June after admitting guilt in a scheme to suck campaign money out of video-poker guys in exchange for not putting illegal gambling high on his to-do list once elected the state's top lawman.

He, his lawyers and family pleaded for no jail time, but prosecutor William Behe stressed that Preate "horribly abused" the public trust and endangered confidence in the office of attorney general. For good measure, Behe called Preate "hypocritical," "haughty" and "self-absorbed."

Sitting in the courtroom, I heard Preate, the tough-talking combat marine, address U.S. District Judge Sylvia Rambo in a wavering voice, blubbering, "This is the most painful day of my life. I will take this personal pain with me all the days of my life. It is unrelenting. There is no respite, even in the dark of night."

I remember thinking oh, brother, even in the dark of night?

Preate got fourteen months and a $25,000 fine. By the time he got outside the courthouse in front of the statewide press, he also got a new attitude.

"I can do federal prison standing on my head," he said.

He added, "I'm a tough guy. I'm not afraid to do time. I did my time in hell in Vietnam."

Ah, I thought, the Ernie I know.

And to show what a small circle Pennsylvania politics can be: Ridge replaced Preate with an appointee who'd figure prominently in future state doings—former Western Pennsylvania U.S. attorney Tom Corbett.

BACK TO THE FUTURE OF TOM RIDGE

By 1996, and governor less than two years, Ridge's name was on short lists for vice president.

This despite glitches like ham-handed efforts to bring major shipbuilding to the Philadelphia Naval Shipyard, promising not to cut higher education funds then recommending just that, and promising not to cut medical assistance then doing just that. You know, like the pay raise thing.

But Ridge was popular in a state with lots of electoral votes, so he was getting national attention, even in 1996.

And he was feeling good.

"It's tough to ignore the reality that Pennsylvania and me personally got a lot of positive attention," Ridge told me during the GOP convention in San Diego. "Pat Buchanan didn't want me to be vice president, but I guess that's not all bad."

The '96 convention was a last stand for GOP moderates, a dying, or at least ailing, breed. There was scant enthusiasm for Dole and a general sense among younger Republicans that the party needed to move to the right; the fact that it did hurt Ridge's chance of getting on the ticket in 2000. More on that shortly.

QUICK CONVENTION STORY

Talk about back to the future, here's a note from the '96 convention that speaks to political consistency.

Freshman senator Rick Santorum, then thirty-eight, was not a fan of Dole or political moderation.

Even as Dole was being nominated, Santorum was selling a different message, one he'd offer, almost verbatim, sixteen years later.

During a sit-down off the convention floor, this is what he told me: "The values that once held us together as a country are under a huge assault, and the government is a part of that. We've allowed for too much individualism."

This would be a central theme in his 2012 bid for president.

He went on: "The system has taken the place of the family, and it's destructive. It's not the government's job to feed everybody. Don't tell me they'll starve, and they'll die. I don't believe that."

He added that government should be cut and that GOP leaders should take "a more activist role in promoting spiritual activity," such as school prayer.

"Is Bob Dole going to lead the charge on a lot of these things?" Santorum asked.

"Probably not," he answered.

Remember, they were on the same team.

Ridge easily won reelection in '98, beating veteran Democratic Pittsburgh lawmaker Ivan Itkin (who many in the press—okay, maybe only a few of us—referred to simply as "comrade") 57–31.

It was a horrible campaign, so let's have an Arlen story.

SPECTER (AGAIN) BEATS THE REAPER

In June 1998, Arlen had open-heart surgery and an extended hospital stay due to complications that included pneumonia, a stint on a ventilator and, by his own admission, "eight, nine or ten days" with no recollection of anything.

This was after brain surgery in '93 and again in '96 for removal of tumors that proved to be (unlike their host) benign.

At the end of July 1998, I visited Specter in Washington. Here's an excerpt.

> WASHINGTON—*Arlen Specter is working on a meatloaf the size of second base. He's using lots of A-1 sauce. Not the act of a dying man.*
>
> *We're in the Senate Dining Room. The place drips history and oozes import.*
>
> *Democratic legend Robert Byrd (alleged by Arlen to have "paved-over" West Virginia when chairman of Appropriations) stops by to drop good wishes.*

"Glad to see you lookin' well, Ah-len," says Byrd.

Former Sen. Dave Durenberger leaps from a nearby table to proclaim Arlen "a medical miracle." He taps Arlen's chest, cuffs Arlen's shoulders. The Capital Gang's Mark Shields, dining at the next table with Sen. Mary Landrieu, says hello. So does Joe Biden.

Arlen's in his element. One of the most exclusive clubs there is. Basking in the goodwill of the high and mighty. Seemingly enjoying it. And why not? Just a few weeks back he was flirting—maybe more than flirting, maybe actually trading body fluids—with the Grim Reaper.

…The clogged artery that caused the pain that sent him to the hospital is nicknamed "the widow-maker" because it can, if clogged enough, produce a wham-bam, keel-over, dead-when-your-face-slaps-the-floor heart attack.

But here he is. Walking rather than riding the underground Senate tram; eating meat instead of salad; seeking ice cream and complaining about yogurt.

—Philadelphia Daily News, *July 27, 1998*

RIDGE II

In Ridge's second term, things heated up for "the guy nobody ever heard of."

Texas governor Bush was seeking the White House, and it took no time for Pennsylvania media to add Ridge to the ticket.

In June 1999, Bush announced his candidacy and made his first campaign visit. He did some schools and a fundraiser with Ridge in Philadelphia. Press was invited. We all sat around in a classroom at Visitation BVM Catholic grade school in North Philly and asked Bush questions he declined to answer.

Bush called Ridge his "good buddy." Ridge called Bush "my good friend." They both said they cared about kids and education, and that was just about it.

Asked about picking a VP, Bush said, "My personal criteria for a running mate will be 'can the person be president?'"

Asked if he thought Ridge could be president, Bush said Ridge isn't running for president, adding, "Thankfully."

Asked if a pro-choice candidate such as Ridge could be nominated to the national ticket by a party with an abortion ban in its platform, Bush said, "My first focus is whether this party is willing to nominate me."

About all we could get out of Bush regarding Ridge was, "I'll tell you this, he's a good man."

And all we got out of Ridge on the VP stuff that day was, "As long as I have known Governor Bush, we have never discussed it. It's never even been inferred."

But the drumbeat continued.

By April 2000, with the GOP convention scheduled in Philadelphia in late July, Ridge seemed well positioned to snag the spot.

He helped Bush with Catholics, moderates and Democrats. And polling showed with Ridge on the ticket Bush easily carried Pennsylvania.

Ridge was coy. He repeatedly said, "You don't run for vice president." And once during a one-on-one hallway ambush interview when I said, "I know you probably won't answer this, but have you been the subject of background checks?" he laughed, said, "You're right," and quickly walked away.

Speaking of laughing, here's an excerpt from a column under the headline "Talk of Guv as VP is Not Just a Tall Tale."

Tom Ridge, a.k.a. the next vice president of the United States, has this big horse laugh.

You know, head back, mouth wide open, loud braying noise.

I don't get to see it often because, believe it or not, the governor doesn't find much of what I say and write all that funny.

But I saw the laugh the other day when we were hanging out together, him doing gubernatorial things, me looking for an up-close assessment of how he's handling his VP attention.

I said, "Whaddya think of the talk that you're just too tall?"

The laugh starts. Like an explosion.

"You haven't heard that?" I ask.

"NO!" he chokes out through the laugh, now in full gallop.

I explain that even national talking heads suggest that Ridge, who is 6-foot-3 and has some bulk, might present a "stature gap" for George W. Bush, who's slightly built and 5-foot-11.

The laugh goes on.

"Well, I guess I could contact some orthopedic surgeons and lose an inch or two," he says, still laughing.

The laugh drops to a trot: "It's ludicrous. It's funny. I can't imagine."

When I suggest he can write the Daily News *headline if he's not picked, he quickly offers, "Too-Tall Tom!"*

—Philadelphia Daily News, *May 2000*

The column was written after spending time with Ridge in Philadelphia and chatting about his chances and interest in the VP gig.

He said he was "ambivalent" and acknowledged no one would believe that. He said even if asked, any decision depended upon his wife Michelle and their two adopted children, then fourteen and thirteen.

When asked about abortion and whether the GOP was ready to dump its pro-life litmus test, he said he sensed the party was moving that way, "but my other sense is we're not there yet."

Asked if he thought the party could get there in a matter of months, he answered, "I don't think so."

Ridge did lots of national traveling on behalf of the Republican Governors Association and the national convention. He also hosted a National Governors Association meeting in mid-July at Penn State, which drew lots of national press and speakers such as Colin Powell, Alan Greenspan and President Clinton.

National media quizzed Pennsylvania journalists about Ridge and his chances. Clearly, there was high interest.

But literally within a week, that all changed.

A CBS News poll said close to a third of Bush supporters were "less likely" to vote Republican if Bush picked a pro-choice running mate. An Associated Press poll of convention delegates showed nearly a quarter could not support a candidate supporting abortion rights.

Insiders had said Bush's pick would rely on "the politics of July," and it was fast becoming evident Ridge would not be picked.

Bush was leading in polls, the GOP was happy, and even though the party was heading to Philadelphia, the home-state boy was fading.

On July 25, Bush made it official. He named the head of his VP search, Dick Cheney, as his running mate.

Ridge held a news conference the next day and confessed he'd pulled himself out of consideration back on July 5. This meant he misled the press and allowed attention and speculation to swirl around him for weeks after he knew it was over.

"I walked a very thin line and there may be some people that say I stepped over it. To that extent I feel badly," Ridge said.

He explained his decision to drop out by saying he and his wife decided the rigors of a national campaign and, potentially, national political life didn't fit well with raising teens. He discounted suggestions he pulled out knowing he wouldn't have been picked.

"Absolutely not," he said.

He stressed his intention to serve out his term, which was to expire in January 2003, and not accept a cabinet post if offered.

He, of course, had no idea what lay ahead.

AN ASIDE: WHICH WITCH?

To radically shift gears and leave this chapter with some lingering fun, here's an item about a Pennsylvania witch/lawmaker.

Long before 2010 Delaware Senate tea-party candidate Christine O'Donnell delighted political types by proclaiming, "I'm not a witch," a member of Pennsylvania's legislature already staked out that ground.

Our state leads in so many ways.

In 1999, a legislator from Ridge's Erie was charged by a former aide of ties to witchcraft and also had some trouble with the feds and local law enforcement over things like missing government property and way too many exotic birds.

I am not making this up.

It is but another oddity of Pennsylvania politics. Here's an excerpt of what I wrote under a headline "It's Eerie When Rep Denies Being Witch."

Next time you complain about your local elected officials, consider this: in Erie, a state House member is denying she's a witch.

Yep. Came right out this week and said, "I am not a witch."

As you might imagine, this made headlines in Erie.

Now, I know people in Philadelphia, including editors at this newspaper, think I make stuff up about the Pennsylvania Legislature.

God knows it sometimes seems that way. They are a squirrely bunch.

But state Rep. Tracy Seyfert, R-Erie, a 57-year old psychologist and former member of Erie City Council, is now on record denying a former aide's charge linking her to witchcraft.

The aide, Marilyn Soltis, resigned along with three other aides in the wake of an FBI raid of Seyfert's property that turned up a 10-ton electric generator and a 500-gallon fuel tank, federal surplus property Seyfert apparently managed to nab for her own use.

She is said to worry about Y2K.

This led to a zoning violation citation from her local township. Well, actually it was the hundreds of screaming peacocks, pheasants and other birds she was keeping that led to the citation.

Hey, at least it wasn't newts.

Local talk radio is reportedly playing "Ding Dong the Witch is Dead;" and there are jokes about Seyfert's answering machine.

"You've reached the office of Rep. Seyfert. This is Beelzebub, spawn of Satan. The representative is out doing my bidding right now. If you'd like to talk to deceased representatives, press one. If interested in government surplus, press two."

Seyfert "Is not doing interviews," said an aide in her Erie office. An aide in her Capitol office (where there are no Halloween decorations) declined comment."

—Philadelphia Daily News, *September 23, 1999*

CHAPTER 5

RIDGE TO WASHINGTON; RENDELL TO HARRISBURG

E veryone remembers where they were the morning of September 11, 2001, the same way older people remember where they were the afternoon of November 22, 1963.

That sunny September day, I was at a car dealer waiting for some maintenance work to be finished. I was in the lobby when the first images of the aftermath of the first plane striking the World Trade Center showed up on TV.

Within a few hours, I was headed west on the Pennsylvania Turnpike toward a place named Shanksville in Somerset County where United Airlines Flight 93 went down thirty miles southwest of Johnstown.

All I knew was I looking for an open field in the middle of nowhere.

Before I found it, I stopped at Somerset Area Ambulance Station 902 and spoke with Andy Barth, one of the first people to reach the crash site.

"There was nothing," he told me, "no bodies, no wreckage, just scattered small pieces of metal. I didn't see anything larger than five or six feet. I'd have never guessed it was a big plane like that."

Later, the hundred or more journalists gathered near the site were taken by buses out to the field to look at what Andy Barth found. A hole in the ground.

What I remember was how quiet and peaceful the scene was, how calm the air. And how sickening the feeling.

This is a piece of what I wrote for the newspaper.

Part of yesterday's attack on America crashed in a field off Little Prairie Lane. And on a day when credulity was stretched to near-impossible limits, there was an incredulous scene here that stole the end-of-summer solace from a patch of Western Pennsylvania and reminded the world that the talons of terrorism reach beyond big cities.
—Philadelphia Daily News, *September 12, 2001*

On the night of September 20, during an address to Congress, President Bush announced that Tom Ridge would be his anti-terrorism czar, a post that would later head a new department of government, the Office of Homeland Security.

We were tipped earlier in the day that the Ridge pick was coming and so had some stories underway when the official announcement was made. In some ways it seemed inevitable: the guy with the all-American life got a call to national service that he could not refuse.

It happened quickly. Discussions started late September 19. A decision was reached the afternoon of September 20.

By that evening, Ridge was seated in the First Lady's box in the House chamber. He got a standing ovation. Standing beside him were British prime minister Tony Blair, First Lady Laura Bush and New York mayor Rudy Giuliani.

It was, of course, a no-win job. If there were no more attacks, credit would go to the president. If anything bad happened, blame would go to Ridge.

But it was a very big deal at a time when the nation was much on edge.

By the end of September, Ridge was isolated, immersed in briefings, going through five telephone-book-sized binders of intelligence and security data.

He took the job without asking the salary. It was $140,000 or about what he was making as governor, except the Washington job didn't come with a house.

He was paid the White House maximum. Only the president ($400,000) and vice president ($181,400) made more. So Ridge and, for example, national security advisor Condoleeza Rice made the same.

He got Secret Service protection. He was still in Harrisburg. And he was due to report to the nation's capital after resigning as governor October 5 at noon.

In the days running up to leaving for Washington, members of the national press corps would call and ask questions about Ridge.

Mostly they wanted to know what the guy had that made him right for this responsibility and, politically, whether he was being set up to fail so neither

Bush nor other conservatives (read pro-life candidates) would have to worry about a someday Ridge challenge or ever think again of putting him on a national ticket.

Political journalists think all kinds of things.

I would tell callers pretty much the same story.

Ridge, first, was a good soldier. But he was also born lucky and living blessed.

His first pollster, Bill McInturff, of Public Opinion Strategies in suburban Washington, once said: "God wakes up every morning and asks, "What can I do for Tom Ridge today?'"

McInturff told me that in Ridge's first congressional campaign in 1982 he was running in a Democratic district with 17 percent unemployment in the worst cycle for the GOP since Watergate, against a 35,000-vote registration edge.

Ridge won by 729 votes and went on to serve a dozen years.

Then, as discussed, Ridge faced a better-known opponent in the 1994 primary for governor, until legal problems caught up with and sank Ernie Preate Jr.

In the '94 General Election, Ridge was in a dead heat with Mark Singel until a killer released by a board Singel chaired killed again. Ridge won by five points.

Then came seven years of a strong sustained economy from which Ridge and other governors (including Bush) benefitted greatly.

The VP stuff? I now believe Ridge always was ambivalent. Back then, anytime I asked, "Why do you want to be vice president?" he'd answer, "That assumes I do."

And then, with his term running down and no apparent alternatives ahead, came a tragedy that offered another opportunity and presented him with a challenging national post.

THE EXIT INTERVIEW

On Ridge's last day in office, he gave his last speech as governor to the Greater Philadelphia Chamber of Commerce in the Pennsylvania Convention Center. The place was packed.

After the speech, I accompanied Ridge and his security detail, in silence, out a back door to parked but running vehicles to take us to the Philadelphia airport.

Tom Ridge at his last news conference as governor in October 2001. *Barb Johnston/ Philadelphia Inquirer.*

Ridge agreed to let me fly back with him to Harrisburg, I think because of that line I used that he later used about being "the guy nobody ever heard of." I think it was sort of a beginning and ending kind of thing that appealed to him.

I was surprised he agreed, because on issues such as the pay raise, the pension-grab, welfare cuts, sports stadiums and more, I wasn't always generous in praising his agenda, policies or positions. In fact, I once wrote that a Ridge budget plan for more prisons and less welfare could be called "the white man's dream."

But because Ridge always was personable when I saw him, I was convinced his staff didn't let him read stuff that cast him in a negative light, which in the case of the *Daily News* happened with some frequency.

So there I was, flying with Ridge for the first one-on-one press interview he granted since tapped by Bush for the big new gig.

He was candid and sobering.

When asked if he had any idea what new national security efforts might cost, he said, "none," then added, "it begins with a 'b' and ends with an 's.' He said America was "at war," but when asked how we'll know if we're

winning and whether we'll win, he paused for several seconds. He finally said, "I'm not absolutely certain there'll ever be a time when government can guarantee it."

In his farewell address to the legislature a week before, Ridge said, "We will be safe." I asked if that was a promise or a wish. "An aspiration," he said, "a goal. I think it would be foolish to deny the probability, perhaps even the inevitability, of further terrorist attacks in this country…this is a condition that we're going to have to live with for some time, until we break the networks, not just Osama bin Laden, but other cells and other people who put us in harm's way."

We talked about his past and his unknown future. He seemed resolved, realistic in his outlook. He might even have understood he was about to descend into a tangle of bureaucracy, turf battles and an unforgiving global spotlight.

He was about to become the most visible Pennsylvania politician since President James Buchanan.

AN ASIDE: RENDELL GETTING READY

On a lighter note, in the summer of 2000, former two-term Philly mayor Rendell was chairman of the Democratic National Committee and a lock to run for governor two years hence.

I'd known Rendell since he was district attorney in the 1980s and interviewed him many times as district attorney and mayor. He was accessible, smart, funny and a good quote.

So at the convention in Los Angeles where the party would nominate Vice President Gore, I made a point of spending time with Rendell.

One day turned out to be instructive and entertaining. Here's an excerpt from how I described it.

> *LOS ANGELES—Ed Rendell is seething.*
> *It's early morning. He's stomping around the driveway of the Doubletree Hotel on Wilshire Boulevard way out in Westwood, punching numbers into a cell phone, spitting curse words like a sailor in a storm.*
> *He can't find his car or driver. And he is not happy.*
> *This after storming out of an Oregon delegation breakfast where he was supposed to speak, but where Health & Human Services Secretary Donna Shalala and Massachusetts Sen. John Kerry are speaking.*

"*This is no way to do this!*" snaps Rendell, his face a twisted scowl, "*this is crazy!*"

So begins another day for Philly's own "Convention Ed," former "America's Mayor," current general Democratic chairman.

It will get better…

The car shows up with aide David Yarkin. Inside, three phones ring constantly. Files litter the back seat. Events are spread out and can be 30 minutes apart, not counting oft-clogged freeway time.

It's a command post on wheels. He is besieged with requests from major donors: floor tickets, skybox seats, party invites, cars.

Over-booking is a problem. A dinner with President Clinton after his Monday night speech had 400 seats and 550 tickets. Rendell ended up outside with 150 "really pissed-off" big spenders.

For a bash at the West Hollywood hot spot Sky Bar, there were 1,900 invitations. Capacity is 750. Rendell spent the night pleading with the fire marshal, mobbed by donors.

Worse, cell phones keep cutting out—it's an L.A. thing—causing Rendell to rant and rave and curse and sputter, and then to laugh.

He and his driver, 33-year old Los Angelino Mark Holmes, do a bit that involves Holmes imitating Rendell's growling, gravelly voice.

"*Oh! L.A. sucks!*" says Holmes.

"*L.A. sucks!*" echoes Rendell. They both crack up.

They launch into a routine, pretending to field donors' requests.

"*You suck! Hang up the phone!*" hollers Holmes.

"*Where you been all year? You haven't done s--- for us!*" yells Rendell.

They scream at traffic, mock their chances of being anywhere on time. "*NOT in the cards!*" Again, howls of laughter.

They revel in tales of junk food, each calling out the name of local favorites. "*Fatburger!*" yells Rendell. "*Oki Dog!*" offers Holmes.

These are clearly people punchy with fatigue.

Rendell says he's getting three and a-half hours of sleep a night.

Holmes logged 109 hours in one week driving Rendell in a black Cadillac DeVille with tinted windows for $56 an hour.

Holmes occasionally pops in a set of false crooked teeth. Rendell swears Holmes was normal when they met.

"I ruined a human being. I feel some responsibility for him. I might have to bring him back to Pennsylvania," Rendell says.

Holmes adds, "I'll never be the same."

At the posh Bel Air Hotel in Beverly Hills, Rendell hosts a "thank you" luncheon for corporate donors. California wine flows. Avocado salad. Salmon. The butter at each place setting is shaped like a swan. An elegantly dressed woman plays a harp. There are no fatburgers.

And at this event, Rendell finds a New York real estate mogul to pick up a $25,000 tab of overcharges Clinton and his entourage ran up at the pricey St. Regis Hotel.

—Philadelphia Daily News, *August 16, 2000*

BACK TO RIDGE IN THE HOT SEAT

In January 2002, after Ridge was in his new post three months, I was granted an interview in the White House. His office was in the West Wing, steps from the Oval Office but closet-sized; his desk took up almost all the space.

He hadn't had a great start: there was an unresolved anthrax scare; the only thing he tried to do—create a new border control agency by combining Customs, Immigration and a few others—was shot down; the conservative Heritage Foundation called him useless; and *Vanity Fair* ran a posed, grim-faced photo that made him look like Dr. Mengele.

In his office, I saw an action-figure, Buzz Lightyear, from the movie *Toy Story*.

Ridge says, "I shoulda hid that," and explains it's a gift from a staffer because the *Vanity Fair* piece referred to Ridge having a "Lightyear-like jaw line."

We talk about the national security plan he's charged with delivering by July. We talk about a series of vague states of high alert no longer being issued because he's working on a new system to debut soon.

He claims he's not frustrated or discouraged by less than rave reviews and sinking poll numbers. He has, he tells me, "a pollster of one, a focus group of one; and that's the president."

Most of my questions are met with answers that only glance at information. Most of his answers refer to his work as an ongoing process. So I ask, flat out, can you give me a tabloid answer? What *have* you done?

He says he's not sure what a "tabloid answer" is. I explain it's short and has a verb. He nods and says, "We have made progress. We have heightened security and made America more secure every single day since we took office."

It struck me a tad vague. I thought Ridge was in over his head.

Then things got a little worse for him.

At the end of February 2002, there was a story in the *Washington Post* about his family (wife, two teens, three dogs) continuing to live in the Pennsylvania Governor's Mansion at taxpayers' expense four months after he went to Washington.

It wasn't a new story in his home state, but it was now a national story. It quoted some Democrats saying Ridge should reimburse state taxpayers. And it came on the day the Associated Press reported Ridge's personal portfolio had a bunch of stocks in companies vying for security-related contracts.

Suddenly national hero Lightyear was a freeloader looking to cash in.

Where did it come from? I figure in true Washington insider political tradition, it came from his friends, which is to say, the people in his party who feared his potential for national political appeal.

There was already a line forming to replace Veep Cheney in 2004. And as one GOP player told me, when a line forms, "the night of the long knives will begin."

Then came the color code.

COLOR ME SKEPTICAL

In retrospect, the Homeland Security Advisory System, aka the color code, did more to harm Ridge's overall image than any stories about his family living in the mansion or anything in his portfolio.

The color system was instant fodder for comics.

Here's what Jay Leno said: "Tom Ridge has set up a five-stage, color-coded system to warn Americans against threats. The colors are green, blue, yellow, orange and red. This is what the Republicans meant when they said they are trying to get more color in the party."

Conan O'Brien said, "Red means we're in extreme danger. And champagne-fuchsia means we're being attacked by Martha Stewart."

Tina Fey on *Saturday Night Live* said, "Strom Thurmond was visibly enthused about the plan, saying, 'A colored alert system? I've been waiting for one of them for years.'"

And the comedy troupe Capitol Steps did a knock-knock joke: "Knock, knock. Who's there? Orange. Orange who? Orange you glad it's not red?"

Here's an excerpt from a column I did on the system.

Signe Wilkinson. Philadelphia Daily News.

The color thing worries me. It's more like something out of Mr. Rogers' Neighborhood than a serious attempt to communicate with adults.

I mean why not have a "Mr. Uh-Oh" hand puppet announce heightened levels of national alert?

"Oh no, everybody, Mr. Uh-Oh says, duck, roll and cover."

I got the official White House paperwork on the new system and guess what? It says zip: three single-spaced pages of gobbledygook.

For example, the yellow "elevated condition" we're all in now calls for "increasing surveillance of critical locations; coordinating emergency plans as appropriate with nearby jurisdictions; assessing whether the precise characteristics of the threat require the further refinement of pre-planned protective measures; and implementing, as appropriate, contingency and emergency response plans."

Huh?

What does that mean exactly?

Reads like some emergency planning official worked himself into an "elevated condition."

Please tell me six months after the horrific attacks we are further along than a set of colors and a few pages of bureaucratese.

Fearing I might be over-reacting, I checked with some political experts.

William J. Green, a Pittsburgh-based political consultant and long-time Ridge fan and supporter, said, "Green's safe, that's good," but asked, "where are these lights going, on top of the Gulf Building?"

Philadelphia state Sen. Vince Fumo, a frequent Ridge critic, said, "All I know is I always go through yellow lights."

...I'm not sure how colors help people feel secure, prevent terror or protect our borders. Maybe the thinking is we gotta do something public, what can colors hurt? Fair enough.

I just hope the next step isn't defense planning on Etch-a-Sketch.
— Philadelphia Daily News, *March 2002*

THE GOVERNOR RIDGE LEFT BEHIND

With Ridge gone to Washington, the state was in the hands of Lieutenant Governor Mark Schweiker because the state constitution says so.

Schweiker was a former township supervisor and county commissioner from Bucks County outside Philadelphia and was Ridge's handpicked running mate in '94 to balance Ridge's northwestern base. He was affable and good-looking.

He was a fine steward of the state after Ridge's departure, and he drew lots of national attention for his role in the rescue of nine coal miners trapped for seventy-seven hours inside the Quecreek Mine, Somerset County (same county where the 9/11 plane went down), in July.

Because Schweiker went to the scene, showing up in jeans, staying for days, and because the rescue was so successful, he got raves, including in the *New York Times*, which cited his "executive mettle."

As miners were brought to the surface, he helped carry a stretcher and even climbed into the rescue capsule to see what it was like. I thought it all was a tad hot-doggy but was willing to cut him slack since it was summer and the legislature wasn't in session and he wasn't running for anything.

Then he went too far, and I couldn't resist. Here's an excerpt from a column under the headline "I Was Gonna Give the Guv a Break, but..."

Yesterday, at two news conferences, Schweiker showed that side of himself that seems to say it's all about me and I don't know when to stop.

First, at Conemaugh Memorial Medical Center in Johnstown with five of the nine miners at a news conference that was supposed to feature them, Schweiker took over.

He talked about how when he visited one miner, Thomas Foy, in his hospital room Sunday, Foy told him to "make it quick" so he could watch NASCAR on TV.

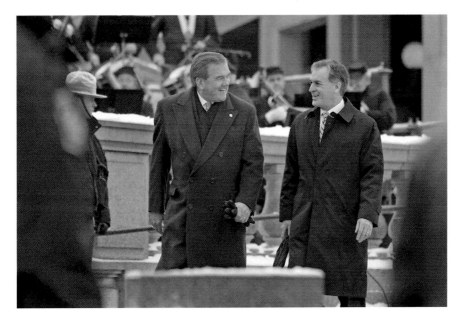

Mark Schweiker, right, became governor when Governor Ridge went to Washington. *John Whitehead*/Patriot-News.

Not hard to picture.

Then Schweiker went on at length about how the nine were "saved twice," once with right-on-target drilling to get them air, and again when they were brought up.

I couldn't help thinking if Schweiker went on much longer, they'd need to be saved a third time.

Then he started talking about how he had tickets for The Who in concert last Saturday night. "I like The Who," he said, "one of my favorite bands."

Oh, brother.

Then, back in Harrisburg, he held a non-news conference to announce a special commission to investigate the accident. This despite the fact a joint federal-state investigation is already under way.

He couldn't say who's on his commission or when it might do what. But he did say the state was "not just going to talk the talk; we're going to walk the walk."

OK.

He added, apparently without a shred of awareness, "we need to get to the bottom of it."

Today he flies to Los Angeles for an appearance on "The Tonight Show with Jay Leno."

State plane to Chicago, commercial jet the rest of the way. Staying over with two aides and state troopers. No doubt all on our tab.

"It's a compelling story that caught the world's attention," said spokesman Dave La Torre, "People are eager to hear about this."

Now, I understand disaster politics forever changed after 9/11 and every officeholder wants to be Rudy Giuliani. It's the price we pay for lionizing the former New York City mayor in his finest hour.

But Schweiker isn't Rudy. He isn't Dick Thornburgh who calmly managed Three Mile Island so long ago they didn't have cell phones. He isn't Frank Keating who shined after the Oklahoma City bombing.

And he isn't the guy—Bob Long, a 34-year old engineer from Somerset—who pinpointed where to drill to get air and later an escape capsule to the trapped nine.

I wouldn't mind hearing from, or even about, Bob Long. But I think it's time Mark Schweiker takes a slide.

—Philadelphia Daily News, *July 30, 2002*

THE 2002 RACE FOR GOVERNOR

At the start of the year, I thought the Democratic primary for governor would be close. I even gave an edge to young Bob Casey, the forty-one-year-old auditor general and first-born son of the late governor, against fifty-eight-year-old Rendell.

I thought the Republican candidate, Mike Fisher (who'd gotten, on bad advice, hair plugs before the election) had, despite being twice elected attorney general, no chance.

There was "the cycle." There was Casey's name. And there was Rendell's prowess. So I focused on the Democrats.

They could not have been more different. Rendell was electric, with a loud crackling personality that could fill a room and leave them laughing. Casey was staid and stoic.

Rendell was a poet, singing songs of possibility, a proponent of progressive wide-open growth: tax, spend, build and develop, full-speed ahead; riverboat gambling and, to pay for expanded early education, "slots for tots."

Casey, like his father, was pro-gun, pro-labor and pro-life; more priest than poet, more preacher than songster: protect the elderly, provide for the

needy, preserve resources for those (as his father used to say, quoting Hubert Humphrey) in the dawn of life, the twilight of life and the shadows of life.

Rendell had tons of money and a story about saving an American city, for which Gore dubbed him "America's Mayor" before somebody else gave the title to Rudy Giuliani. And Rendell was the "adult," experienced in dealing with trouble.

But Ed was also an urban Jewish liberal in a rural, socially conservative state. He supported abortion rights, gun control and gay rights in a commonwealth known for hunting, blue-collar workers, hate crimes, the toughest anti-abortion laws in America and (west of Philly's City Line Avenue) a profound dislike of Philadelphia.

It's just that he's one heck of a politician. And that was on display from the get-go.

In January, I moderated a debate with Rendell, Casey and Fisher. Only Rendell seemed out front, pushing, selling and advocating. Casey and Fisher were cautious, as if waiting for poll numbers on every issue.

Rendell called for slot machines at horseracing tracks and gambling on riverboats to raise money for schools. Casey and Fisher opposed it. Rendell called for gun controls to help reduce violent crime. Casey and Fisher opposed it.

And when I asked each to name a living person in public life they considered a good example of public service, they each showed something of themselves.

Fisher went first and named George W. Bush. There was a snicker in the room, but the pick was Republican and safe. Rendell went next and, demonstrating deft politics, named his wife, U.S. Third Circuit Court of Appeals judge Midge Rendell. Casey, despite the fact that he bore the task of convincing voters he was more than his father's son, ignored the "living" part of the question and named his late father.

During the primary, Rendell worked hard. After airing TV ads, he hit the road and stayed on it. He visited every part of the state. He went to the diners and the dinners, met all the local politicians and as many of the locals as he could. They'd recognize him from TV ads and from his gig as a Comcast sports TV analyst after Philadelphia Eagles games.

Once when with Rendell at the state Farm Show, an indoor agricultural expo held annually in Harrisburg, I noted he got more comments about football than politics. I remember thinking his love of sports (and visibility because of it) was an asset of more than a little value. It helped him connect with average voters.

By the way, doing a Farm Show with Rendell is a hoot. He showed up in his usual dark suit, white shirt and tie. He looked so out of place that one farmer by a giant tillage machine felt it necessary to explain to him that corn "grows in rows."

Later, Ed was petting a lamb that a young teen was shearing for show. I assume Ed thought the lamb was a pet because he asked what happens to the animal after the weeklong event.

"We slaughter it," the boy deadpanned, looking at Rendell as if he'd just landed from another planet. The future governor quickly withdrew his hand from the soon-to-be-delicious lamb.

After I wrote about Rendell at the rural event, including how out of place he seemed everywhere but the food court, his campaign manager David Sweet said only this: "You're never going anywhere with him again."

Of course, I did go places with him again. He won the primary in May. And it wasn't close. Casey ran a mostly negative, often sloppy race. Rendell spent heavily on TV and won 56–43 to face Fisher in the fall. He won that, too, 53–44, on a message that he saved Philly, cut spending and balanced its budget, created jobs, started all-day kindergarten and froze property tax assessments for seniors.

What he really won it on was his personality and the "charisma gap" suffered by Fisher, a gap evident on the campaign trail.

Rendell was a machine with an instinct to connect: kids, men, women, didn't matter. He'd compliment kids on a t-shirt or hat. He'd talk sports with men. He'd tell women, "I love your hair," or "I love your freckles."

Sure, it was corny. Yeah, it was trite. But I so often saw it work. He had the ability, innate or developed, genuine or contrived to make people like him. Like Reagan or Clinton, both of whom were twice elected president despite problems and issues that swirled around them.

Call it life force, charm or personality. Whatever you call it, Rendell had it by the boatload. Fisher couldn't buy it on sale at an outlet.

Two quick examples: campaigning at the Exton Mall in suburban Philly, Rendell approaches a guy standing outside a gift shop. The guy says, "You got my vote if you can get my wife outta that store." Without missing a beat, Rendell asks, "What's her name?" Told it's Marianne, he walks into the store and calls out, "I've got an announcement, everybody. Marianne needs to leave the store at once!"

She's at the checkout counter and laughs out loud, as does everyone in earshot. Outside, her husband, a Republican, confirms that Ed will get his vote.

Contrast that to Fisher. He was campaigning in Hershey, speaking to residents of a Country Meadows, one of a chain of assisted-living facilities for the elderly. He tells them, "My mother died at Country Meadows."
I'm thinking, what? Like many of you will soon?
You could *feel* Fisher trying to connect. You could watch Ed do it.
On November 5, 2002, Rendell became the first Pennsylvania governor from Philadelphia since 1914.
There are those who'll quickly add, "And the last."

AN ASIDE: THE '02 RACE FOR LIEUTENANT GOVERNOR

Because Pennsylvania politics is not right in so many ways, candidates for lieutenant governor run separately in primaries rather than as a part of a ticket.
In 2002, Catherine Baker Knoll, who finished third in the '94 primary for governor, won a nine-way primary for lieutenant governor.
She got 25 percent of the vote.
One of the more unusual events of the cycle was a Democratic debate among the candidates that included the following highlights.
I should mention I'm not making this up.
Knoll strongly asserted she always had and always will want to "help the female people."
Green Tree Borough (south of Pittsburgh) councilman Ron Panza, who the moderator kept calling "Mr. Panzer," said, "For the record, I am anti–toxic waste."
Edward Truax, a Harrisburg artist and writer sporting a dangling cross earring and a haircut that can kindly be called non-traditional for a political candidate announced he'd been "in a coma" for a month.
Given the office he was seeking, this could actually be an asset.
One candidate, Scott Conklin of Centre County, withdrew from the race *during* the debate. No one could blame him.
And rambling, often incomprehensible answers to questions on gun control were so painful that the *Inquirer*'s Tom Fitzgerald, next to me at the press table, leaned in to whisper, "I certainly believe in the Second Amendment right now."
The next day, Panza (or Panzer), clearly proud of his performance, told me in no uncertain terms, "I know I won't finish last."

Catherine Baker Knoll at an alpaca event in May 2006. *Ed Hille*/Philadelphia Inquirer.

He didn't. He finished sixth. With 7 percent of the vote.

And that's how Catherine Baker Knoll, affectionately known as CBK, became Rendell's political partner, lieutenant governor and, as she often was called, the woman "one cheese steak away" from being governor of Pennsylvania.

THREE RENDELL CAMPAIGN STORIES

There were three memorable stories from the '02 campaign about money, sex and money. They offer a peek at how a pure politician operates.

In April, I wrote about the fact that in 2000, as head of the Democratic National Committee, jetting all over the country raising dough and campaigning for Gore, Rendell taught two classes of one hour each at the University of Pennsylvania (which gets millions of state taxpayer dollars) for which he was paid $90,000.

One class was Monday afternoon, one was Monday evening. They were both on (what else?) government and politics.

That same year, he took home $252,322 from the Philly law firm Ballard Spahr for rainmaking and billable tasks he later described as basically doing nothing.

The year he pulled $90,000 from Penn, his undergraduate alma mater, the median salary for full-time college profs was $46,330 and the highest-paid 10 percent of college faculty at Ivy League schools such as Penn made $88,000, according to U.S. Department of Labor data.

Certainly there were full-time, tenured Penn faculty members making more. But they also carried full teaching loads, did research, got published, held office hours, submitted to peer reviews and attended department meetings.

Rendell showed up two hours a week.

But then Rendell and Penn had a long-standing, mutually beneficial relationship.

When he was mayor, Penn did what it wanted in West Philly, including blocking a proposed professional baseball stadium near Amtrak's Thirtieth Street Station near the campus. And the year Penn paid Rendell $90,000, Rendell donated $10,000-plus in stock to the university.

When I was putting a column together, Penn confirmed Rendell's employment but wouldn't discuss details. When I asked Rendell campaign manager Dan Fee if Rendell cared to comment, Fee said, "He's at a rally at Penn."

I asked, for what, higher pay?

The sex story centered on Rendell's reputation as having a fondness for the company of women (more on this later), especially the tall blonde variety, and had more twists than a TV soap opera.

It focused on tall, attractive blonde lobbyist and long-time Rendell pal Holly Kinser. She lobbied for Philadelphia when Rendell was mayor. She was divorced from Democratic House Leader Bill DeWeese, who blamed Rendell for the divorce and told anyone who'd listen that Rendell stole his wife. He'd also attach adjectives to Rendell's name that were less than flattering.

(DeWeese later went to prison for misusing public funds for campaign purposes. I always thought he should have pled insanity.)

Rumors of Rendell and Kinser were rampant, as were rumors the campaign of straight-laced Mike Fisher was preparing a TV ad linking the married former mayor to the formerly married lobbyist.

One night in September in a Harrisburg hotel and then in a nightclub, Kinser, no shrinking violet, confronted the rumors head-on.

In an elevator and in a restaurant at the Harrisburg Hilton, she went at Fisher's media guru, John Brabender (who'd also help run campaigns for Tom Corbett and Rick Santorum), demanding to know if ads were planned that questioned her relationship with Rendell.

Brabender said no.

Later that night in a club called NOMA across the street from the Hilton, Kinser confronted Fisher campaign manager Kent Gates on the same issue but with a tad more gusto.

Witnesses said Kinser, who towered over Gates, began a conversation saying, "I hate your guts," then jabbed a finger in his chest saying, "Don't you f—k with me!"

The scene was described as boisterous, uncomfortable and antagonistic.

"Yeah, that's a fair characterization," Kinser told me later. "Sometimes I can be a very candid person." She denied using the f-word.

The Fisher camp was more amused than anything and one insider said for fun they were thinking of titling every TV ad offered for traffic "Holly."

The other Rendell money story involved tax returns.

Rendell spent much of '02 dodging requests for his tax returns. He was under no obligation to release them but had done so in the past. Fisher released his, and Rendell said he would, too; so the press kept asking for them.

By fall, he claimed he needed IRS extensions because of "complicated" real estate stuff connected to his Ocean City, NJ, beach house. Then his campaign blamed his wife, Midge, for not getting the right paperwork together on time.

And when the returns were released *the Thursday before Election Day*—at which point it was pretty clear Rendell would win—we all found out why.

Not only was there another $250,000-plus from Ballard for doing (by his own admission) next to nothing, there was nearly $300,000 from a stock options deal with a Pittsburgh businessman who gave Rendell's campaign more than a half-million in loans and gifts.

As a board member of this guy's communications company, Com-Net, Rendell got $25,000, and when the company was sold to Tyco, Rendell's stock options brought him $279,118—all for basically being this guy's pal.

The "complicated" land issues turned out to be something an H&R Block intern could have handled, and hiding behind Midge's skirts or, in her case, robes, left a bad aftertaste.

As you've likely guessed, I wrote about this. Here's the end of a column written as a "memo" to candidate Rendell the day before Election Day.

While folks who actually work for their money lose jobs, pensions, 401-K savings, it strikes me as a tad contradictory for you to be on the campaign stump condemning corporate greed and extolling a government that cares for "its most vulnerable" while also raking up the bounty of business excess.

Your Com-Net deal alone is worth 10 times the state's median household income.

I think you realize this. I think that's why you hid it. And I think that's why you misled us all.

But, hey, congratulations on tomorrow's win. At least you earned that.
—Philadelphia Daily News, *November 4, 2002*

CHAPTER 6

The Rendell Years
(and Other Fun Stuff)

Because Ed Rendell wowed state voters with a well-run campaign, he came to the Capitol with plans for a "New Pennsylvania" and high expectations. In Pennsylvania, this is always a mistake.

In Rendell's case, there were two factors he probably didn't think would matter as much as they did, and do.

One, there's a huge difference between running a city and running a state. City government provides face-to-face services. Mayors command attention at any time in any part of the city. State government is more distant. When a governor travels, news usually occurs only in the media market visited.

Two, as Philly mayor, Rendell never dealt with real Republicans. "Republican" city councilman W. Thacher Longstreth or "Republican" senator Arlen Specter were as close as he got. And even if someone in power was of a different party than the mayor, all concerned were pulling for the same goals and results.

But Pennsylvania's regions have different goals and seek different results, and so varying ideologies tend to mean sharper edges statewide than citywide. In short, Pennsylvania has "real" Republicans. For Rendell, that was a new experience.

Plus, Rendell as mayor was known and praised for energy, talent and vision. In Harrisburg, such gifts aren't important or even valued.

By July of his first year, his initiatives were in idle and his relationship with the legislature was toxic. In a column under the headline "Why Rendell's Plans for Pa. are Stymied," I sought to explain.

I have a theory.

And as July slides into August and Ed's "New Pennsylvania" (slots, more money for schools, wage- and property-tax cuts) slides toward oblivion, it seems as good a time as any for theories.

Mine's based on last year's election. Rendell won by 323,827 votes out of 3.5 million cast, a clear victory; for an open-seat in a governor's race, a larger than normal win.

But his margin was about equal to the number of votes he got in Philadelphia. And he carried only 18 of the 67 counties, basically the eastern side of the state and the far southwest.

The vast middle, 49 counties one could call Pennsylvania's psychological center, voted for Republican Mike Fisher.

Rendell won the most populous counties: 11 of his 18 have more than 200,000 people; only six of Fisher's 49 have more than 200,000.

So what?

Well, as a longtime observer of the Legislature, I believe its soul and its core interests are a lot closer to Fisher's 49 than to Ed's 18.

I discussed this with Rendell during the campaign. I don't think he got it. Now I think he's starting to.

Pennsylvania's a national leader in spit tobacco, gun ownership and NASCAR fans. Not that there's anything wrong with that. Just that we tend to lean right. And lawmakers reflect the lean.

But it's more than conservatism. It's mistrust of government and resistance to change, with the latter slightly outweighing the former. It's why we have State Stores. It's why a popular Republican Gov. Tom Ridge couldn't get school vouchers. It's why lawmakers' reelection rates top 90 percent. It's why Ed's "New Pennsylvania" is nowhere.

—Philadelphia Daily News, *July 30, 2003*

That first year, Rendell had budget woes, an ugly state police sex scandal, a health-care and medical malpractice crisis driving doctors out of Pennsylvania and constant bickering with the legislature.

He also was taking on an image he'd find hard to shake: he was a Philadelphian, not a Pennsylvanian; he was governor of Philadelphia, not of Pennsylvania.

His polling numbers sagged. I wrote that we should trade him to California for Governor Arnold Schwarzenegger.

Rendell's first budget, due in July, didn't pass until late December. It included a $1.3 billion tax hike covering personal income, cell phones, cigarettes and increased fees on birth and death certificates.

One conservative Republican, Representative Scott Hutchinson, of Venango County, said, "Ladies and gentlemen, welcome to the 'new' Pennsylvania. No bold new ideas. No property tax relief. Just more state taxes, more state spending."

Rendell couldn't get out of 2003 fast enough.

AN ASIDE: ARLEN RUNNING FOR REELECTION

Because Arlen Specter was every bit the campaigner Rendell was, and because Arlen faced reelection in '04, he was about the business of making sure he'd win.

That meant getting through a contested primary against young conservative Congressman Pat Toomey. And that meant making efforts to appeal to the right, a wing of the party that never liked or trusted him.

But few used their office more effectively than Arlen.

Take, for example, a public hearing he convened as chairman of some Senate subcommittee on a state and federal holiday in February '04.

Specter, a supporter of abortion rights, used the no-news day for an event in the state Capitol, in conservative Central Pennsylvania, on a subject conservatives love—sexual abstinence.

It was covered lid-to-lid by the Pennsylvania Cable Network, which broadcasts statewide.

Specter sang to the choir, displayed his Senate seniority and showcased his embrace of the George Bush White House, which was seeking to double abstinence-education funding.

A parade of handpicked witnesses praised Specter and thanked him.

One, the Reverend Kenneth Page, talked about $78,000-plus per year in abstinence-education money to rural Clinton County, adding, "Those were funds that you, Senator Specter, were instrumental in providing."

Ever the ham, Specter leaned forward and said, "I'm sorry, I didn't hear that."

It was shameless, and politically brilliant.

Afterward, he said, "I think today's hearing was very, very much worthwhile."

BACK TO ED

Rendell's second year didn't start off strong, but there was fun along the way.

Highlights include a story (and Rendell's reaction to it) in the *Pittsburgh Tribune-Review* about the food bill at the Governor's Mansion.

Remember, Rendell owned a reputation as an epic eater. I mean an eater who takes stuff off your plate at receptions, an eater who you don't stand close to at a buffet, an eater who, on his campaign bus, would drape a towel over his front, grab some food and announce, "This is off the record."

Trust me; it should forever remain so.

But in February '04 the *Trib* got into some gustatory issues that forced Ed to respond and left me little choice but to write about the food fight. Here's an excerpt that ran under a headline "Care and Feeding of Ed."

> *After years of stories, photos, anecdotes about his eating, Ed's now defending two chefs and fast food bills at his Harrisburg mansion.*
>
> *Ah, Pennsylvania.*
>
> *Promised property tax cuts, economic development, expanded gambling and environmental cleanup?*
>
> *Nah. Let's talk about Ed craving chicken wings, and the First Lady's breakfast.*
>
> *"She has one English muffin with peanut butter and coffee every day," Ed says.*
>
> *This in response to a* Pittsburgh Tribune-Review *story saying taxpayers spent $75,918 on food during Ed's first 11 months in office.*
>
> *For comparative purposes, the paper notes the governor of Ohio, Bob Taft, has a part-time chef and an annual food budget of $14,000.*
>
> *But we bought Ed five times that, including $7,752 of produce, $1,067 of herbs and flowers, $876 in bottled water and 500 pounds of cold cuts and cheese.*
>
> *Hey, ya gotta have hoagies!*
>
> *There's also mention of Ed's love of Da Pits, a rib joint cattycorner to the mansion (he got ribs, wings and shrimp there for his 60th birthday dinner last month), his late night snacking and his passion for pastries.*
>
> *The newspaper notes that since only Ed and Midge live in the mansion their average eating cost is $230 a day.*
>
> *Anyone who's seen Ed eat knows this isn't automatically out of the question. But there is more to the story.*
>
> *The governor's office, employing all the good sense of a plate of coleslaw, refused to cooperate with the newspaper which was forced to use the state's Right-to-Know Law to even look at the food bills.*

Once the story was published, and bantered on talk radio in Western Pennsylvania, Ed and his chief of staff, John Estey, sat down with Trib *reporter Brad Bumsted and (forgive me) spilled the beans.*

The governor took time from creating the "New Pennsylvania" to explain he and judge wife ate only about four grand of grub.

The Guv said, for example, he ate 155 mansion breakfasts at an estimated $3.50 per, and the First Lady ate 120 at maybe $2 each.

He said, "The $2 for the judge is probably high."

You know, cuz it's just a muffin and coffee.

Most of the mansion's food bill was to cater 189 events and feed state cops and 13 full-time mansion staffers (yes, 13, and, yes, in the house of our cost-cutting "I've-been-a-bear-on-reducing-spending" Guv).

But catering costs are down $42,000 from when party animal Mark Schweiker lived there. (Waiting for rebuttal from that front.)

All of this, apart from the stunning scene of the governor of a major state explaining $2 breakfasts, redraws attention to the way Ed eats.

—Philadelphia Daily News, *February 23, 2004*

Ed's eating got lots of attention. Some called it endearing, humanizing, a political asset; others, a bad example.

He had sandwiches named after him. Thick, rich, high-fat sandwiches: Buffalo chicken strips and bleu cheese at Wawa; ground steak with Greek dressing and cheese on a soft pretzel at The Spot in Harrisburg.

Veteran Harrisburg gadfly Gene Stilp, an Ed fan, started a campaign to prevent Ed's "nutritional suicide." Stilp had one thousand buttons made showing a cheese steak with a line through it and bumper stickers for Ground Hog Day: "Please Gov. Rendell: Don't eat the Ground Hog."

Then March '04 brought two fun Ed stories, one about a new state slogan and one about Ed's nickname, "Fast Eddie," which would entangle Lieutenant Governor Catherine Baker Knoll.

First the slogan story.

It's common for new governors to push tourism and often a new state slogan.

Normally, some politically connected, high-priced ad agency gets a contract and new welcome signs go up at state borders with a new slogan and the new governor's name.

Rendell, to his credit, took a different route. He announced a citizens' name-that-slogan competition. Online voting would pick a winner. And the winner would get a week's vacation anywhere in the state worth up to $5,000 of donated food, travel and lodging.

Immediately there were jokes about second place being a two-week vacation.

There were also suggestions from the class-clown crowd: "Pennsylvania, It's Alabama-plus;" "Pennsylvania: Cooking with Coal;" "Pennsylvania: 'Deliverance' with Scrapple."

Rendell said the new slogan would go on signs where the governor's name would normally go. He was offering tax savings, citizen participation and personal humility, a win-win-win.

Of course it got screwed up.

The winning entry was submitted by seventeen separate contestants, and so the winner had to be selected at random.

The winning entry was "The State of Independence." The randomly selected winner was thirty-five-year-old Tristan Mabry, of Philadelphia, a Bryn Mawr College poli-sci prof finishing his doctorate at Penn.

Given Ed's fondness for and relationship with Penn and his adherence to all things Philadelphia, eyebrows were raised.

But the real problem was the slogan already belonged to Swedish auto manufacturer Saab, which had ads saying, "Saab, welcome to the state of independence."

So Pennsylvania, land of potpie, potholes and a legislature as progressive as the Ming Dynasty, had a new slogan that was a car commercial.

I, of course, loved the story and suggested it followed a state tradition of theft.

I noted that past slogans such as "Pennsylvania, Naturally" belonged to "Vermont, Naturally," and "Memories Last a Lifetime" was used by Ocean City, New Jersey and, I think, some massage parlor in York.

"Independence" won with 33 percent of the vote, hardly a mandate. The first runner-up—in the event, I assumed, the winning slogan for any reason (including future litigation) couldn't serve—was "Discover Our Good Nature," which sounded like an ad for a supermarket chain. The second runner-up, "Liberty Loves Company," sounded like a porn film.

As of this writing, "State of Independence" remains Pennsylvania's slogan.

The second fun story that March had to do with driving. Rendell, since he was Philly district attorney in the '80s, had the nickname "Fast Eddie." I'd heard it came from his willingness to quickly take plea bargains to keep criminal dockets clear and run up conviction wins. Others say the nickname is tied to his penchant to deal on anything in order to get whatever he wants quickly.

In March '04, the nickname took on another meaning.

My then-*Daily News* colleague, Nicole Weisensee Egan (now with *People Magazine*), broke a story that state police clocked the governor's limo, driven, ironically, by state troopers, at triple-digit speeds on the

Pennsylvania Turnpike between the Capital City and Philadelphia nine times in a few months.

Riding the left lane, lights flashing, over 100 miles per hour.

The story said one trooper gave chase until called off on a police radio by Rendell's driver but that cops were concerned such consistently high speeds represented risks for Rendell and others.

Rendell declined to be interviewed for the story. His press secretary, Kate Philips, said the governor would never ask anyone to break the law and that he worked, read or was on the phone while in the car, paying no attention to the speedometer.

I, of course, weighed in.

Do not for a second suggest you're an innocent passenger on the road of life or on the road between Philly and the Burg.

I been there, pal. Been in the car with you at 105 mph on the turnpike or, as perhaps it should now be known, "The Eddiebahn."

Remember?

It was the '02 campaign and you, as always, were running late and so urged, I'd say vigorously urged, campaign driver/sidekick Charlie Breslin, aka Chaz Braz, to go, go, go. And go he did.

I remember leaning forward for a gander at the ol' speedometer and thinking, geez, 105 seems a tad extreme to get to an endorsement by the mayor of Steelton, a borough of 5,000 some 85 miles west of Philly.

But, hey, such is life in the fast lane.

And it wasn't the only time I was in your car when traffic safety took a backseat.

I zipped through South Philly and Center City with you as you bounced up and down in the front passenger seat, offering words of encouragement such as "faster, faster!"

And the only thing, as I recall, diverting your attention from the need for speed was a street corner Dunkin' Donuts.

"Mmmm," you said at a red light, "Dunky doughnuts."

"We don't have time for dunky doughnuts!" barked Breslin as he punched the big black Chrysler through the intersection.

So it's no surprise to me that you were clocked busting a hundo in your trooper-driven Edmobile.

Hey, why not just add an "executive lane" to the turnpike? Or get a hovercraft. Or amend the new state slogan: "Pennsylvania, the State of Independence From Traffic Laws If You Happen to Be Its Governor."
—Philadelphia Daily News, *March 29, 2004*

The story only got better the next day when, acting on a tip, I semi-stalked Lieutenant Governor Catherine Baker Knoll after being told that she, too, had a speeding issue.

This was a Thursday. The source said she was stopped Monday.

As per the constitution, the lieutenant governor serves as president of the Senate. So near the end of a Senate session, I stationed myself between the Senate chamber and the LG's office.

I'd also been waiting for the chance to ask her face-to-face about her dog, Boomer, a pet she brought to work, a pet I'd been told her troopers had to walk and a pet that traveled with her.

I'd heard the dog's full name was Boomer Baker Knoll. I wanted confirmation.

When she emerged from the Senate, she wasn't happy to see me. I'd recently written that she was a little "loopy" and noted she more than once in public called Edward G. Rendell "Edward G. Robinson."

I asked if she'd been stopped for speeding on Monday. She said no. I asked if she'd been stopped for speeding recently. She paused, thought and said, "Maybe one day last week."

Yes, she and her assigned trooper in her big state car, a black Lincoln Town Car, were stopped on the turnpike between Harrisburg and Pittsburgh.

She said she "wasn't really" speeding, just "going too fast for conditions."

When I asked if she, like Ed, sits in the front passenger seat, she said, "It depends. If I have Boomer Baker Knoll with me I sit in the front."

A twofer: admission of a speeding stop and confirmation that she gave her dog her family name. I wrote it was "just another day in the fast lane."

SPECTER VS. TOOMEY

The '04 GOP Senate primary was something I never expected. I was wrong about Pat Toomey. When I interviewed him before the race, I pegged him another patsy for Specter. He wasn't. He was tough, focused and got big-time financial help from the national conservative Club for Growth, which he later would run.

(Plus, of course, the party's true conservatives continued to hate Arlen.)

So on election night in April, sitting in the *Daily News* newsroom in Philly, I starting writing the top to three different columns: Arlen upset, Arlen survives, race too close to call.

And just as deadline threatened to strangle news, the Associated Press called the race for Specter. He won by just 1.6 percent.

The headline on the column was "Specter, the Warrior, Survives." Here's a piece.

He survived the single-bullet theory, Robert Bork, Anita Hill, brain tumors and a heart attack. What's a right-wing statewide novice and the Club for Growth to him?

Just another hurdle.

Not that Pat Toomey, a Harvard cum laude, young, smart and personable, was a pushover. He ran an effective, funded, focused challenge: Arlen's too liberal, spends too much money, supports abortion, doesn't feed the family values planted at the party's roots; plus, it's time for change.

Wasn't enough. Even though Arlen flashed signs of vulnerability.

While fit and feisty at 74, his age for the first time seemed a factor, at least a presage, a glimpse of Strom Thurmondhood.

And his message, always multiple—he helps those he serves, he has seniority that benefits the state, he's important to his party—was, when it came to Toomey, more shotgun blast than laser.

There was no single bullet.

Remember Lynn Yeakel's waffle? A stunt in '92 when she charged Arlen with waffling on issues, then, before a TV camera, couldn't come up with one example? Did her in.

This was different.

What took Toomey down wasn't negative ads attacking his business dealings in Hong Kong or his family bar or saying, "He's not far right, he's far-out."

In fact such ads might have backfired. Toomey comes across as sincere, honest; it's tough to paint him otherwise.

What won this time is the iron will of Arlen Specter soldered fast to 40 years experience.

What won was Specter's unfailing work ethic and innate understanding of what it takes to win.

Like constant travel to the 67 counties, election year or not.

Like earning endorsements from teacher unions and the NRA.

Like getting President Bush back to Pennsylvania just as Toomey surged in polls, or flying around the state with conservative Rick Santorum, or targeting mass mailings and robo calls and raising/spending whatever's needed, $12 million, $13 million to fight another day.

That and the instinct to cling fast to Bush with a final ad asking voters
to "honor" the president's request and vote for Specter.
Arlen himself insisted on the ad. And wrote it.
"We crossed every 't', we dotted every 'i,' we turned every stone and we
didn't waste a dime," he told me last night.
(So) here he is, two decades-plus a U.S. senator, surviving attacks from
the right, attacks from the left, attacks even from his own body.
He's a warrior who does whatever it takes to find a path to victory.
—Philadelphia Daily News, *April 28, 2004*

Specter is rare. There are politicians, even in Pennsylvania, who are smart. There are those willing to do whatever it takes to get or keep public office. There are almost none who are smart *and* willing.

How anyone in big-time politics endures the mind-numbing sameness of rote speeches, town meetings, county dinners and endless fundraising is beyond me. How he or anyone with intelligence does it is a total mystery.

And so at the GOP national convention that year in New York as the party was re-nominating Bush-Cheney, I wrote about Arlen and my theory of what keeps him going: medical experiments.

I noted that for twenty-four years in the Senate he led massive funding efforts for research. I pointed out when he came to Washington in 1981 the budget for the National Institutes of Health was $3 billion and by '04, it was $28 billion, and that since he started chairing a key appropriations subcommittee, he was pushing to triple NIH's budget.

And I suggested payback: a secret, anti-aging experiment with side effects causing robotic fundraising capacity and unnatural energy levels. How else could he be running for a fifth Senate term at seventy-four after multiple health problems while playing squash every morning and working like a lumberjack?

Here's part of what appeared under the headline "What is Arlen's Secret Potion?"

I think they take him somewhere in or around Bethesda and hook him up
and pump stuff into him.
It's clearly more than squash or naps or cosmetic enhancements (come on,
you know that one's true).
I confront Specter with this theory in the sky lounge of the Pan Am
Building just before he addresses a GOP pro-choice group.
And, I swear, he doesn't deny it.
"That's right," he drawls, "I'm a zombie."

Just the tone is unsettling.
After a Trump Towers fundraiser for Specter last evening, hosted by The Donald himself (the two are 20-year friends; hmm), I tell Trump my theory and ask what he thinks.
He plays dumb: "NIH? Explain?"
After I explain, he says, "Oh, I see. Well I just think he's got great energy. He's a great guy."
He quickly turns and walks away.
Oh, no, he's in on it.
Several calls to NIH seem to confirm things.
Clearly tipped to my suspicions, they initially give me the number of a Calvin Jackson whose recorded message says he's "out" until next week.
How convenient.
Next comes a run-around from an NIH operator who claims there is no overall spokesman.
I persist. Three calls later, I find Jane Shure, a veteran information officer on NIH aging issues.
"Oh, golly day," she says, taking the non-denial to new aw-shucks heights.
She's nice, too nice. When I press, she says, "He does symbolize a whole group of people who stay at work and function at a high level and don't retire."
Hmmm.
I try again. Finally, she claims there is no NIH youth serum but steadfastly avoids direct denial of treating Specter experimentally.
What further proof is needed?
Plus, when I ask Arlen if this is his last election, he quotes Ronald Reagan and says, "The people will tell me."
Yeah, I think. The people at NIH.
—Philadelphia Daily News, *September 2, 2004*

THE 2005 PAY GRAB

Few Pennsylvania political stories created the reaction and lasting fallout of the 2005 legislative pay grab.

It was stunning and obscene. In a year the budget again was late, again offered none of the promised property tax or wage tax relief and reduced medical assistance to tens of thousands of poor, ill and disabled citizens,

lawmakers passed and Rendell signed huge pay increases for themselves, judges, cabinet members and other public officials.

The raise for rank-and-file was $11,000-plus and brought base pay to $81,000-plus. And that didn't include cars, insurance, gas, cell phones, daily expenses, health-care coverage and golden pensions—a benefits and perks package worth another $30,000.

Also, the raises, depending on leadership posts, ranged upward. So about fifty members designated as committee or subcommittee chairmen or vice chairmen had base pay jump to $90,000 and, in some cases, $98,000.

Those in leadership such as House Speaker John Perzel jumped up to $145,000-plus.

The worst of it was how it was done: without public review or a word of debate at 2:00 a.m. on July 7 before leaving town for summer recess.

And, since the state constitution specifically prohibits legislators from increasing their salaries during a term to which they were elected, they called the raise "unvouchered expenses" so they could take it right away but treated it as salary to boost their pensions.

And, calling it "expenses" made it tax-free.

Rendell (his raise was $21,000) signed the thing in private after business hours on a Friday, no doubt ashamed of himself.

It was basically theft. Lawmakers didn't need it, didn't deserve it and weren't (and aren't) worth it, and they took unmitigated flak from all corners of the state from all kinds of media outlets and from an angry and outraged public.

A few weeks later, the story got better.

State Supreme Court chief justice Ralph Cappy, who was a prime mover of the raise, told the Associated Press public reaction to it was "knee-jerk." He said, "I have yet to hear an argument made by anybody that this is wrong based upon its merits."

His pay went up by $22,325.

He also sent an opinion piece to ninety-two daily newspapers defending the raise, calling criticism of Rendell and lawmakers "unfair, superficial and short-sighted" and praising those who voted for it for their "extraordinary courage."

A colleague noted bank robbers also have courage.

I couldn't resist. I called Cappy and suggested he was the victim of identity theft. I told him someone was using his name to say incredibly stupid things.

He laughed. "Very clever," he said.

Then I suggested that maybe his remarks were, to use his parlance, out of order.

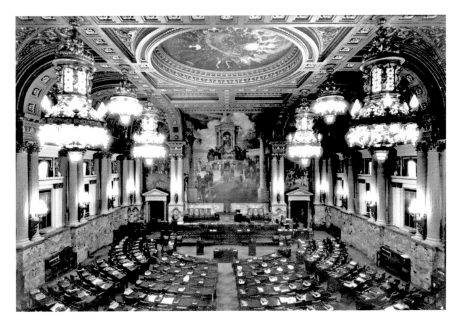

Pennsylvania House Chamber or, during the '05 pay grab, a "scene of the crime." *Mark Ludak*/Philadelphia Daily News.

"I probably used inappropriate words," he told me, "I'm not the most sophisticated person regarding the media."

On that we agreed.

Still, by August, many lawmakers were privately saying the pay raise story would die and public anger would pass.

I wasn't seeing that. My email was jammed with anger from readers. Even people inside the system—lobbyists, legislative employees getting 3.5 percent cost-of-living raises and average state workers whose salaries were frozen by Rendell—still were steaming.

New grassroots groups with names like Democracy Rising PA and PA Clean Sweep sprung up, and lawmakers got more media attention.

It was reported, for example, that House Democratic Leader DeWeese punished fifteen Democrats who voted against the raise by stripping them of lucrative committee posts.

Legislative junkets got reported in detail. The Harrisburg *Patriot-News* wrote how the board of the Pennsylvania Higher Education Assistance Agency, where sixteen of twenty-one board members are lawmakers, spent $884,687 on trips to Napa Valley, the Greenbrier in West Virginia and Colonial Williamsburg.

Another report noted forty-two lawmakers and fifty-four aides went to a conference in Seattle with taxpayers picking up $168,000 of the bill.

And before August was over, some conservative lawmakers started pushing to repeal the pay grab.

That's when Rendell, who enacted the raise, who called it "good legislation," proved again he's a master politician. He said if the legislature voted to repeal the raise he'd "absolutely" sign it.

He clearly sensed something.

By September, things got squirrely. Speaker Perzel defended the raise, claiming migrant cow milkers in Lancaster County made $55,000 a year.

I argued in a column that a milkers-to-lawmakers comparison isn't fair: migrant milkers produce something.

A statewide Keystone Poll showed 77 percent of Pennsylvanians were aware of the raise and, of those, 79 percent thought it unwarranted.

There were petitions and rallies. And the aforementioned gadfly Gene Stilp welcomed lawmakers back to the Capitol from summer break with a twenty-five-foot inflated pink pig and a banner: "Repeal the illegal legislative pay raise."

They did. In November. The Senate vote was 50–0. The House vote was 197–1. Only Democratic Whip Mike Veon of Beaver County voted to keep the raise. He lost the next election. He's now in prison.

Two top Senate Republicans—Bob Jubelirer and Chip Brightbill—also lost the next election. And Perzel later got voted out of office before he went to prison.

THE RACES OF 2006

Former Pittsburgh Steeler Hall of Fame wide receiver Lynn Swann ran against Rendell, and incumbent senator Santorum against Bob Casey Jr., in a campaign dubbed "the son also rises."

Swann was a novel addition to state politics, a football celebrity in a state that worships football, a former Steeler from a region rabid for Steelers. Plus he was friendly and accessible: a self-described pro-life conservative who claimed the hardest hit he ever took was from the IRS.

But he was up against a well-oiled machine behind arguably one of the best retail politicians in state history, the man Catherine Baker Knoll called "Edward G. Robinson."

Plus, there was the "cycle." Swann had no chance.

Which isn't to say there wasn't some fun.

In October, Rendell was interviewed at the *New Era* newspaper in conservative Lancaster County and was pressed on issues related to bringing slot machines to the state—61,000 under legislation passed in 2004.

Yes, he said, there'd likely be more problems with gambling addicts, but there'd also be a big plus for old people.

This is how he put it: "These are people who lead very gray lives. They don't see their sons and daughters very much. They don't have much social interaction. There's not a whole lot of good things that happen in their month.

"But if you put them on the bus, they're excited. They're happy. They have fun. They see bright lights. They hear music. They pull that slot machine and with each pull they think they have a chance to win.

"It's unbelievable what brightness and cheer it brings to older Pennsylvanians. Unbelievable."

Unbelievable indeed.

Again, I couldn't resist. Here's a snippet from a column. The headline was "Ed Plays Craps with the Senior Vote."

> *Wow.*
>
> *Now, no doubt some older Pennsylvanians fit this, to me, amazingly broad-brush, insulting, patronizing and insensitive description; and no question there are older people who spend time and money at slots.*
>
> *But, geez, this is a state of 2.4 million citizens 60 or older, a state ranked third nationally behind Florida and, recently, West Virginia, in percentage of population 65 and older.*
>
> *And the Census Bureau says 79 percent of folks 65 or older register to vote, the highest rate of any age group.*
>
> *You'd think, or at least I'd think, the elected leader of the state wouldn't describe older people as depressed and dull-witted with drab lives made better only by bright lights, music and the belief they can win a bucket full of quarters.*
>
> *At least not in an election year.*
>
> —Philadelphia Daily News, *October 24, 2006*

It is testament to Rendell's prowess that gaffes such as this never impacted his performance at the polls. He won reelection by a twenty-one-point margin.

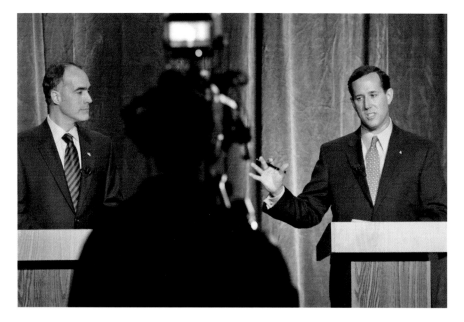

Rick Santorum debates Bob Casey at the National Constitution Center, October 2006. *Jori Klein*/Philadelphia Daily News.

The Senate race got far more attention because of a whiff of upset in the air. Santorum was into immigration and (as always) opposition to homosexuality, gay marriage and abortion. And he came to the campaign with baggage: he stuck a Pittsburgh-area school district for $55,000 in cyber-school costs for his kids who lived with him in Virginia; he said a Catholic priest pedophile scandal in Boston was no surprise since Boston was "a seat of academic, political and cultural liberalism"; and in his 2005 book *It Takes a Family*, he suggested women stay home and raise children rather than work.

Plus he supported the war and President Bush at a time neither were popular. In January, Casey held a twelve-point lead.

Santorum's first campaign TV ad was about immigration. It was Rick to the camera saying, "My father immigrated here from Italy with my grandfather, who worked thirty years in the coal mines of Western Pennsylvania. They came here with dreams of a better life for their family."

(Anyone who followed Santorum's 2012 GOP presidential run may notice some similarity, actually verbatim similarity.)

Then he went on: "Unfortunately, today some enter our country with more sinister intentions. That's why I fought so hard to add thousands of new guards to beef up our borders and for critical high-tech surveillance. To

do anything less is not only dangerous, but an insult to those who have come to America by following the rules."

Many of us covering the race were confused. Are we in Texas? California? Arizona? No. We're in an aging, 86-percent white northeastern state concerned about taxes, jobs and heath care. We didn't get it.

When I asked Santorum's camp about it, I was shown a poll saying when Pennsylvanians are asked if they favor amnesty for illegals, 83 percent say "no."

Fine, I said, that's when asked about amnesty. When asked about priorities, they say taxes, jobs and health care.

So Santorum's message seemed off. By October, it went round the bend. He stumped with a stream of doomsday rhetoric. Democrats put us at risk of annihilation at the hands of radical Islamics. He said in a speech in Lebanon County, "I don't want to win this race for me, but for the country." He called a Democratic victory "a disaster for the future of the world." He ran a TV ad featuring a missile launch and a mushroom cloud that ended with "we just can't take a chance" on Casey.

It was desperate, misplaced and ineffective. He lost by 17.4 points, a blowout. And six years later, he ran for president.

THE VINCE OF DARKNESS

One of the extraordinary stories of Pennsylvania politics is that of South Philly senator Vince Fumo, maybe the most unique politician in state history.

He, of course, went to prison.

But not before he built an unmatched power base and a personal fortune that ran to eight figures.

He owned a bank, held a law degree and a Wharton MBA. He was a member of Mensa, a licensed pilot, a boat captain, an electrician and a plumber. He had so many connections, was so plugged in, that the *Daily News* dubbed him "Octo-Vince."

He was smart and got things done, a classic deal maker. His staff estimated that from 1985 to 2007 as Democratic chairman of the Senate Appropriations Committee he directed $7.9 billion to his district and city.

But as time passed and his power grew, so, apparently, did his flaws.

In the winter of 2007, in his twenty-ninth year in office, he was indicted for fraud, conspiracy, obstruction of justice and more. He was charged with illicitly spending millions to buy a bulldozer for his farm; vacuum

Vince Fumo leaves court in Philadelphia after being sentenced in July 2009. *Yong Kim/* Philadelphia Daily News.

cleaners for each floor in his homes in Philly, New Jersey and Florida; to overpay public employees for personal and political work; to use his board position at a seaport museum to borrow historic yachts for pleasure trips; to spy on old girlfriends; and to use a non-profit he created to buy SUVs and shopping sprees.

The breadth of the indictment was staggering.

A Fumo friend told me at the time, "When he started out, he went to the Jersey Shore for fun and fooled around with boats. Now he goes to play golf in Scotland and takes along a satellite phone."

But Fumo, ever aggressive, preempted the indictment to announce it was coming and labeled it the result of a four-year federal vendetta, complete with "threats, intimidation and frequent leaks to the media."

At the time, the U.S. attorney was Patrick Meehan, a past campaign manager of Republicans Specter and Santorum, with known political ambitions. I wrote that when Meehan v. Fumo was decided, one political career would continue and one would come to an end.

It was decided in 2009. Fumo was convicted of 137 felony counts.

Meehan went to Congress. Fumo went to prison.

ED DEPARTS, CORBETT ARRIVES AND 2010 BRINGS A SURPRISE

The final years of Rendell's reign were marked by more late budgets, odd assertions, a legislative scandal, a blonde controversy, Tom Corbett rising and the fall of Arlen Specter.

All in all, a good time was had—by journalists.

Let's look at Arlen. In March 2009, a year before he'd seek a sixth Senate term, I wrote a column suggesting it might be time for him to "come home," meaning to the Democratic Party.

He said he wouldn't.

But he started as a Democrat and switched to Republican in 1965 to run for Philadelphia district attorney. Now he was one of only three GOP senators to support President Obama's economic stimulus, an act every bit as offensive to conservatives as his opposing Reagan Supreme Court nominee Robert Bork in 1987.

Plus, Pat Toomey, who he narrowly edged out in the '04 primary, was making noise about running again and this time, after heading the limited-government, low-taxes, Washington-based Club for Growth, would have even more support from the right.

Plus, some things changed since 2004.

There were 239,000 Pennsylvania voters, mostly Republicans, who switched parties in '08 so they could vote in that year's Democratic primary between Obama and Hillary Clinton. The majority certainly were moderate Specter voters.

That meant the primary pool for 2010 would be more conservative than in '04, when Specter won by just 1.6 percent.

Signe Wilkinson. Philadelphia Daily News.

Also, Specter in '04 was endorsed by conservatives such as President Bush and Senator Santorum. The only conservatives pushing Specter by 2009 were those trying to push him out the door.

Then in April he walked out on his own.

Here's a piece of a column. It ran under the headline "Arlen's Slick, Hide-Saving Slide."

> *Arlen's decision is self-protective. He himself said as much.*
>
> *He reads polls. He reads people. He saw his all-but certain demise in a GOP primary next May. A Rasmussen Report on Friday put conservative Pat Toomey 21 points ahead. Conversely, a Quinnipiac Poll last month put Specter's approval rating among Democrats at 71 percent.*
>
> *So, despite repeated unequivocal denials that he'd switch parties, despite arguments that Congress needs a two-party system to support the principle of checks and balances, he flipped yesterday and shook up the political world.*
>
> *"I am unwilling to have my 29-year Senate record judged by the Pennsylvania Republican primary electorate," he said at an afternoon news conference. "I'm not prepared to have that record decided by that jury."*
>
> —Philadelphia Daily News, *April 29, 2009*

And so he became a Democrat backed by Obama, Rendell and Joe.
It was classic Arlen. As one colleague put it, "Can you imagine another politician in America endorsed by George Bush and Barack Obama in successive elections?"
Few suspected in April '09 that the move wouldn't work.

CORBETT RISING

The state attorney general, running for reelection in 2008 and already the expected GOP candidate for governor in 2010, lit up the political sky in July 2008.

He announced criminal charges against a dozen House employees, including a Democratic member of leadership, for theft of public money and general sleaze such as handing out jobs and taxpayer-financed bonuses in exchange for campaign work and sex.

This came on top of the legislative pay raise scandal, the Vince Fumo scandal and the legislature's ongoing general ineptness.

After reading the charges, I wrote about a need in Harrisburg for a cathartic cleansing and suggested the same with the immediate use of flamethrowers and fire hoses.

Among the charges were that House Democratic leaders handed out $1.3 million in secret bonuses to public employees working on political campaigns (first reported by the Harrisburg *Patriot-News*); that the chief of staff to Bill DeWeese, Mike Manzo, recruited a twenty-one-year-old college intern as a no-show employee and mistress; that House Democratic Whip Mike Veon used staff and tax dollars to drive his and his wife's motorcycles to South Dakota for vacation then fly back; and that a top House attorney, Jeff Foreman, pulling $126,200 in public salary and $14,815 in bonus pay, maintained a private law practice, billing at $200 per hour, sometimes charging taxpayers for more than twenty-four hours a day.

By December 2009, Corbett netted twenty-five legislative staffers, lawmakers or former lawmakers, including former Republican Speaker Perzel and former Speaker DeWeese.

Perzel, in 2011, pled to corruption charges related to spending millions of taxpayer dollars on computer technology to benefit Republican campaigns. DeWeese was charged with conducting fundraisers at taxpayer

Left: John Perzel pled guilty to corruption charges in August 2011. *Laurence Kesterson/* Philadelphia Daily News.

Below: Bill DeWeese with girlfriend Stephanie Lupacchini at his 2012 sentencing. *Joe Hermitt/*Patriot-News.

expense and using state employees exclusively for Democratic campaigns. Manzo told the grand jury that DeWeese had "no campaign apparatus beyond his legislative staff."

DeWeese, known for boisterous multisyllabic loquaciousness, issued a one-paragraph statement the evening of the day he was charged. It ended with, "Obviously I'm disappointed by today's action."

His disappointment would grow in 2012 after he was convicted by a Dauphin County jury and sent to prison.

A SIDE TRIP TO "EDWORLD"

The '09 state budget cycle was yet another mess, and Rendell slipped into what I called "EdWorld," a place of peace and comfort, often free of context, where he sometimes went when things got rough and from which he offered assertions that were, well, unusual.

The following are among my favorites.

In July, he regaled Pittsburgh TV station WTAE with the fact that he arranged for state workers to get no-interest loans to help them through payless paydays due to his budget impasse.

If a balanced budget isn't in place July 1, the state technically can't spend money.

But Rendell was selling himself. Because of the loans for state workers, said Ed, "They should put a statue of me up on their mantel." He later said, "I was kidding," but a TV clip of the statement sure didn't look like he was kidding.

It looked like he was visiting "EdWorld."

He also claimed that because he declined to take his annual, automatic cost-of-living salary increase that he somehow took "a pay cut."

On a statewide call-in show, he said that refusing increases over two years meant "essentially" for him a 6 percent pay cut. At a Capitol news conference not long after, he escalated that to it being "exactly the same" as a pay cut.

I noted in a column that when one's salary stays the same (his was $170,150 at the time), that's not a pay cut. Lots of people lost jobs and, therefore, all their pay. Lots more suffered pay cuts because their pay was reduced. But the only place Ed took a cut was, you know, in "EdWorld."

Also, like many politicians, he displayed the art of selective comparisons and descriptions.

His push for another hike in the personal-income tax was offered as amounting to a "modest" increase of $4.50 a week or $234 a year for an average taxpayer.

Yet when touting his property tax rebates to homeowners from slot-machine revenues, they were labeled "significant."

The average rebate at the time was $189 a year.

So $234 is "modest," and $189 is "significant."

It was a nice example of how when politicians play Santa Claus, the gifts are large; when they play Scrooge, the take is small.

It was also an example of how much fun Rendell was to cover.

THE SISTERS ORIE AND FAMILY FEUD

One of Pennsylvania's best made-for-TV political stories in 2010 involved two powerful Pittsburgh families, the Ories and the Zappalas.

Remember former state Supreme Court justice Stephen Zappala from his days of being accused of trying to run down another justice with a Mercedes?

Well, take a deep breath.

Justice Zappala became Chief Justice Zappala. His son, Stephen Zappala Jr., became district attorney of Allegheny County in Pittsburgh. Another son, Greg Zappala, was linked to (but never charged in) a Wilkes-Barre judicial scandal. He was part owner of a string of juvenile jails to which judges sent kids in exchange for cash (and later went to jail; the judges, I mean). A daughter, Michelle Zappala Peck, narrowly lost a judicial race in '09. A brother, Charles Zappala, was in a group that lost a bid for a state gaming license in '07. And he, the former chief justice, was head of the Pennsylvania Casino Association, a trade group where daughter Michelle was employed.

On the other side, the Ories included state Senator Jane Orie, a member of Senate leadership; state Supreme Court justice Joan Orie Melvin; Janine Orie, an aide to the justice; their brother and, for a time, their lawyer, Jack Orie; and another brother, Jerry Orie, who worked for Attorney General Corbett.

As you can see, both families were busy. And there was a time Senator Orie, a Republican, and District Attorney Zappala, a Democrat, both were mentioned as possible candidates for state attorney general. Plus, there was contention between the tribes due to the fact that Senator Orie opposed gambling in the state, something in which the Zappala clan clearly had an interest.

Jane Orie in the state House chamber just before her 2012 trial. *Chris Knight*/Patriot-News.

Soap opera–esque, yes?

So when District Attorney Zappala charged Senator Orie and her sister Janine with conspiring to use state resources, tax dollars and employees for political campaigns, including that of sister/justice Joan, their brother/attorney Jack Orie lashed out.

He said witnesses heard District Attorney Zappala vow to indict anyone "who f—s with my family" and promise, in a reference to the sisters Orie, "those bitches are going down."

In recounting this story in a column, I had to add, "I love this state."

I also raised the issue of why Corbett, who investigated the same sort of misdeeds by other lawmakers, didn't investigate Senator Orie; and, conversely, why didn't the Allegheny County district attorney turn over

the case to the attorney general's office, given that it fell nicely into work underway there?

The answers I got were fuzzy and leaned on things like "original jurisdiction." All that's certain is the edge in this feud is currently with the Zappalas.

Senator Orie was convicted in May 2012 and sentenced to two and a half to ten years in prison. Justice Orie Melvin was indicted the same month and relieved of court duties. Both she and her sister Janine were awaiting trial as of this writing.

THE 2010 CAMPAIGNS

There were contested primaries in both parties for governor and senator, but only one race drew attention.

And that attention, at least early on, was largely from out of state because national media liked the story of long-time Republican Specter, in power since the state was a Quaker province, running as a Democrat.

He was up against Congressman Joe Sestak from suburban Philadelphia, a thirty-year navy man who worked in the Clinton White House and retired as an admiral. He's a Naval Academy graduate with a master's and a PhD from Harvard.

But he was a novice in statewide politics in a state where it's tough to win the first time out. He was down in most early polling by twenty points or more. Specter's fundraising was nearly double Sestak's. And Specter had the support of the state and national Democratic leaders.

The state party chairman, T.J. Rooney, publicly said Sestak had no traction and should exit the race.

But Sestak was driven. One day in January he did eleven events. His campaign issued more press releases than the federal Bureau of Engraving and Printing issues folding money: in batches every day, from 7:30 in the morning until 10:30 at night.

Still there was talk Sestak might drop out and run instead to keep his House seat. He denied it. When I asked him in February about facing long odds, he told me, "This is going down to the last week, and I know I'll win."

I thought he was wrong.

Even after their one debate, things didn't look good for Sestak.

I moderated the live, hour-long encounter at WTXF-TV Fox 29 in Philly and thought Specter, at eighty, showed he still had it while Sestak, at fifty-

Joe Sestak campaigns for the Senate primary in May 2010. *Alejandro Alvarez/*Philadelphia Daily News.

eight, really didn't bring it. Specter was snarly and aggressive. Sestak was smiley and soft.

And after the debate was over, Arlen kept at Sestak in the studio. Specter snarled, "Do you want to continue this?" I heard him utter the word "fisticuffs," but by the time I turned and focused, he was rendering an unceremonious wave-of-the-hand dismissal at his much younger opponent.

But that debate was May 1. The primary was May 18. And just before the primary, Sestak ran a TV ad that cost Specter his Senate seat.

The ad, ironically, was done by the same Philly-based agency, The Campaign Group, that represented 1992 Democratic Senate candidate Lynn Yeakel who lost to Specter after being hurt by a Specter ad using her own words against her.

This time, The Campaign Group got even. It produced an ad using Specter's own words. It tied Specter to Republicans unpopular with Democratic primary voters: President Bush, Senator Santorum and Sarah Palin. But its punch came from a clip of Specter speaking to someone off-camera and smiling as he said in a drawn-out voice, "My change in party will enable me to be re-ELECted."

The Specter clip played twice, once near the start of the ad, again near the end. A narrator said, "Arlen Specter switched parties to save one job: his, not yours."

On May 18, Sestak got 53.9 percent of the Democratic vote; Specter got 46.2 percent.

It was a rare political surprise in Pennsylvania, the only surprise of the year.

In the General Election, Corbett won the governorship with a promise to clean up Harrisburg and not raise taxes. It was a lackluster campaign to which almost no one paid attention. Democrat Dan Onorato, chief executive of Allegheny County, had so much trouble getting noticed that he ran an ad in which he talked to the camera explaining how to pronounce his name.

And because of all the attention the legislature got in recent years due to its pay raise and scandals, both Corbett and Onorato pledged to enact term limits, cut its size and end members' perks and slush funds, all of which, of course, was hot air since such reforms, however needed, rest solely in the hands of lawmakers.

But it made for good TV. It's just that Corbett had better TV, plus "the cycle," and so he won the governorship, taking office in January 2011.

Senator Specter, with wife, Joan, after conceding the 2010 primary. *Charles Fox/* Philadelphia Inquirer.

Pat Toomey running for Senate in October 2010. *Akira Suwa*/Philadelphia Inquirer.

Meanwhile, Pat Toomey, who narrowly lost to Specter in '04, narrowly beat Sestak in 2010 to get to the U.S. Senate where he has, in his first term, steadily built a reputation as a serious, effective player in national fiscal policy.

He is, as they say, someone to watch.

But enough about serious policy.

THE BLONDE CONTROVERSY

There long was talk of Rendell seen with women other than his wife. The excuse was always linked to the fact his wife is a federal judge and thus banned from political events. Still, in '97 there was speculation about divorce. In 2000, Bill DeWeese publicly said that Ed stole his wife. And in 2010, rumors reached an even higher level.

Ed Rendell and Kirsten Snow lunching at Famous Deli on Primary Election Day 2010. *Tom Gralish*/Philadelphia Daily News.

On Primary Election Day in May, Ed showed up at Famous Deli in South Philly, a place pols and press traditionally go for lunch each election. He brought a tall, striking blonde more than twenty years his junior, a former Miss Pennsylvania and Mrs. Pennsylvania, who worked as his director of media services.

Lots of heads turned.

Rendell and Kirstin Snow (always introduced by Ed as Dr. Snow; she has a PhD in business administration, through "distance learning," from Southwest University in Kenner, Louisiana) were spotted in public many times in Harrisburg—at restaurants, at Snow's son's soccer games and on Snow's boat on the Susquehanna River.

But now they were together in the nation's fourth-largest media market. The *Daily News* ran a photo of the pair shot through a deli window. And the event became central to a subsequent *Philadelphia Magazine* piece: "The Governor, the Blonde and the Rumor Mill."

The mag piece featured a posed photo of a seated, suited and smiling Rendell with a smiling Snow standing behind his chair resting her arms on his shoulder. It looked like a formal family portrait. Or a pol's holiday card.

It led to dozens of news stories across the state that angered Rendell. Both he and (twice-divorced) Snow denied an affair. Ed said they were friends and "no way" was he thinking of leaving his wife, Midge. He said he'd "had it with the media," that the issue was personal and "don't ask me again."

I, of course, wrote about it. I argued any anger or embarrassment involved was solely self-inflicted. The headline was "It's the Guv's Behavior that Fuels the Rumor Mill." Here's a piece of it.

> *Point is, no one would have asked in the first place were it not for Ed's penchant for parading around with attractive blondes who are not his wife.*
>
> *In just his time as governor, there was lobbyist Holly Kinser, ex-wife of indicted former House Speaker Bill DeWeese; Leslie McCombs, former Pittsburgh TV anchor turned lobbyist; and now Kirstin Snow.*
>
> *All three "friendships" got media attention, some similarly handled. A 2007* Daily News *column, for example, about the Guv and McCombs— who at the time was in apparent violation of state lobbying law—carried the headline "Guv, the blonde & lobbying law."*
>
> *It included a photo of Ed sitting next to McCombs at a Pittsburgh Pirates game.*
>
> *Then there are the things that Ed said to the mag.*

He said he brings Snow to fundraisers to add "pizzazz"—in EdWorld, a compliment; in the real world, an insult to professional women and akin to calling Snow eye candy.

He said that rumors about him are unfair to attractive women, inexplicably adding, "I should go out and find an unattractive woman to have an affair with." What's that supposed to mean? New hope for unattractive women?

His comment that he gets "hit on by women all the time" I'll let stand, except to note that the last time I heard talk like that was in a locker room in high school.

This is not Bill Clinton with a 21-year old intern or Eliot Spitzer with a high-priced call girl, or Mark Sanford using state resources to "hike the Appalachian Trail."

No one I'm aware of questions Snow's job performance. No one alleges misuse of state funds. But no one who knows Rendell is the least bit surprised by his latest "friendship" or rumors attending it.

And, Ed, you know why.

*—*Philadelphia Daily News, *June 28, 2010*

Within a month of leaving office in January 2011, Ed and Midge Rendell announced an amicable separation. Dr. Snow, as of this writing, continues to work for Ed, helping manage his multiple jobs as *Daily News* sports columnist, MSNBC-TV political analyst, lawyer, consultant and more.

No one bemoaned Rendell leaving public life more than I did. For journalists, covering him was like visiting a shooting gallery on a state fair midway. It was fun. He was a constantly moving target you sometimes could hit, even if it often felt you were playing a rigged game.

He genuinely believed in the power of government to improve the lives of those it serves, yet he was famous for helping friends and allies.

Despite a recalcitrant legislature, he managed to push through massive spending increases, mostly for education. But this earned him the nickname "Ed Spendell" and likely doomed any Philadelphia candidate from winning the governorship for a generation.

He brought the state slot machines and table games but failed in efforts to gain reforms such as campaign-finance limits, term limits for lawmakers and merit selection of judges.

Some might say he brought us vice but did little to bring us virtue.

THE ANTI-ED

The first time I interviewed Tom Corbett was after he'd been named by Governor Ridge in 1995 to serve as attorney general in the wake of Ernie Preate.

I noticed in his office an old-school metal lunchbox: "Tom Corbett, Space Cadet," a 1950s comic book, radio and TV character. I asked whether he thought it was a good idea for a politician to associate himself with a space cadet.

He sort of laughed. He clearly saw nothing wrong with it.

During the 2010 campaign, I used the "space cadet" reference to question his political judgment on some aspect of how he was running his race, and when I saw him at a candidates' forum, he said, "I knew you'd be the one to bring that up."

I told him I'd given him, years earlier, fair warning.

But here's the thing: Corbett, who was an assistant district attorney, a U.S. attorney and an appointed then twice-elected attorney general, is far more prosecutor than politician.

In addition, he's not flamboyant. He's not a policy wonk. He's not a glad-hander. And he's not a fan of big government. He is, in short, the anti-Ed, something he constantly pointed out as a candidate and early on as governor.

In his first year, with the help of a Republican-controlled legislature, he stuck to his promise of no new taxes but fell somewhat short of "cleaning up Harrisburg."

Instead, the GOP agenda included: extending "happy hours" in bars and restaurants (remember, Pennsylvania controls booze); extending gun owners' rights to fire away when feeling threatened; making it tougher to obtain abortions; and making it harder for some folks, especially minorities, the poor and elderly, aka the Democratic base, to vote.

(House GOP Leader Mike Turzai of Pittsburgh, one year later, told a Republican gathering that this latter measure, a voter ID bill that became law in 2012, would "allow" Republican Mitt Romney to carry the state in the presidential election.)

I wrote about the GOP agenda and Corbett's first budget a few days before he signed it. Here's an excerpt. It ran under a headline "Reforms in New State Budget? Don't Hold Your Breath."

Despite Corbett's pledge to clean up Harrisburg "day one," by say, reducing fat legislative reserve funds or getting lawmakers to pay at least what other state workers pay for primo health-care coverage, any cleanup seems on hold.

Tom Corbett at his inauguration in January 2011. *Ed Hille*/Philadelphia Inquirer.

When I ask the guv if the budget includes reforms, he pauses and says, "I think we'll have to wait until we see the finished product."

By "finished product," I assume he means the complete evolution of planet Earth.

Same goes for GOP House Speaker Sam Smith's proposal to reduce the size of the Legislature. Or various proposals to end lawmakers' automatic pay raises, or hold a Constitutional Convention, or enact campaign-finance reform, or get public unions to take pay cuts or pay more for benefits.

As usual, we get far more rhetoric than results.

Kinda like the guv's promise to cut state vehicles to save money, followed by four new SUVs for himself, the first lady, lieutenant guv and second lady.

I ask a few reform-minded lawmakers what happens to reforms.

"They fall by the wayside," says Sen. Mike "Citizen Mike" Folmer, R-Lebanon County. "We didn't tackle any hard stuff."

Folmer doesn't take the Senate health-care coverage or the pension. He gives back his automatic raises. He takes no per-diem expenses. He doesn't use a state car or charge for mileage.

"They get tired of me talking about Article II, Section 8 of the (state) Constitution," says Folmer. The section says lawmakers' compensation shall consist of salary and mileage and "no other compensation whatsoever."

You can understand why they wouldn't want to talk about it.

Rep. Gene DePasquale, D-York County, pioneered putting his expenses online. He also sponsored legislation to make it easier for third-party candidates to seek office, to allow voting up to 15 days prior to elections and to make all state contractors list political contributions as part of their bids for work.

None of this moved.

"The only thing I've seen happening is cuts to education and hospitals," he says. "My sense is the governor put a higher priority on the cuts and, in an effort to get the cuts, probably canned the reforms."

So it goes: because it's easier to cut something than to fix it; easier to talk reform than to make it happen. But, hey, enjoy those longer happy hours.

—Philadelphia Daily News, *June 27, 2011*

By the end of 2011 and into 2012, Corbett was caught up in the Penn State child-sex scandal, which he investigated as attorney general. He was criticized for how long it took to bring charges against former PSU assistant football coach Jerry Sandusky.

Signe Wilkinson. Philadelphia Daily News.

And Corbett later drew some fire as a member of the university's board of trustees (upon becoming governor), which was roundly criticized for lack of leadership in an investigation of the scandal by former FBI director Louis Freeh.

Corbett answered critics by contending such cases take time to build and that, because the case was active when he joined the board, he was bound by grand jury secrecy not to discuss it with other members, or anyone.

Then by mid-2012, Corbett's second budget passed with no new taxes but not without controversy.

It ended a state assistance program that provided $205 a month to roughly 61,000 low-income people who were, for example, temporarily disabled, caring for elderly or infirm relatives or were victims of domestic violence—estimated savings, $150 million.

At the same time, it promoted a $1.7 billion package of tax credits and incentives for Shell Oil to build a petrochemical plant in Western Pennsylvania that promised tens of thousands of jobs.

Because Corbett got $1 million-plus in campaign contributions from energy and gas concerns, then pushed Shell after opposing taxing the energy industry's extraction of natural gas from Marcellus shale, he took heat.

He was anti-people. He was pro–big business.

It didn't help when the administration dropped tens of thousands of poor kids from health-care coverage, many inadvertently, as part of an effort to

purge Medicaid rolls, and the *Daily News* ran a front-page Photoshopped image of Corbett as the Tin Man from *The Wizard of Oz*, complete with oil funnel cap, and questioned whether he had a heart.

Corbett responded on Philly talk radio, WPHT, saying, "Everyone who knows me knows I have a heart...I'm doing this job because I have a heart."

This inspired *Daily News* Pulitzer Prize–winning cartoonist Signe Wilkinson to agree with the governor in a toon depicting things his heart loves, though I'm pretty sure the governor didn't agree with Signe.

THE EGG MAN

Some of the journalistic fun in the Capitol during 2011 was provided by a member of Corbett's cabinet, Health Secretary Eli Avila.

He was dubbed "The Egg Man" after the *Philadelphia Inquirer* reported he had a run-in with the owner of a deli-like diner called Roxy's across the street from the Capitol.

Story was Avila was unhappy with eggs he was served and pulled a "Do you know who I am?" on the owner, called down city health inspectors on the place and blocked the owner from competing for a contract to run the Capitol cafeteria.

Delicious.

Then Avila made news for ordering SWAT team–type jackets for himself and senior staff with DEPARTMENT OF HEALTH on the front and back and, for himself, a badge with SECRETARY OF HEALTH curled around the state seal (which, by the way, is a sailing ship, a plow and three sheaves of wheat...I don't know. I told you the state is strange.)

When questioned about the need for jackets and a badge, the department's answer was so its employees can better respond to "emergencies."

I weighed in.

I wrote a column expressing concern about what bad health things might be out there. I went to the department's website to see what "emergencies" it dealt with. The most current news release at the time was headlined "Department of Health Confirms Rabid Kitten Found in Williamsport."

I am not making this up.

The kitten was black and orange and found abandoned, I suggested no doubt followed by klaxon sounds and shouts of "Don your jackets, men!"

To be fair, the department also found a rabid cat, a black and white one, in Lawrence County a month before, so, you know, somebody over

there was clearly keeping up with "emergencies" or at least preventing CATastrophies (sorry).

Avila's run-in with the deli owner ended up in court. Avila, in filings, denied saying "Do you know who I am?" or blocking the owner from a state contract. Some legal aspects of the case were pending as of this writing.

RICK'S RUN

Pennsylvania got national attention in 2012 because of the surprising showing of its former senator, Rick Santorum, in GOP primaries.

I never believed Santorum could advance based on (a) covering him and (b) having some sense.

Many were stunned that he offered what appeared to be a legitimate challenge to the national GOP and its inevitable nominee Mitt Romney. I was stunned that few seemed to be looking at the big picture.

So for President's Day 2012, I wrote a column seeking to provide the long view.

I had predicted after Rick's strong showing in Iowa (a caucus where he was declared the winner by one-tenth of 1 percent, weeks after the fact) that the national media would get to know him the way Pennsylvania media did and would find, as Pennsylvania voters found in '06, that his core beliefs and personal traits are untenable in any general election.

That didn't happen.

Instead, the national media ignored Santorum after Iowa because he was finishing third or fourth in subsequent primaries in New Hampshire, South Carolina, Florida and Nevada.

Then in early February, he had three "wins:" in low-turnout caucuses in Colorado and Minnesota and in a non-binding primary in the "Show Me" state of Missouri.

Still, national media did not show me the roiling Rick many Pennsylvanians came to know. Instead, it elevated him (as it previously did Donald Trump, Michele Bachmann, Herman Cain and Newt Gingrich) to the level of alternative to the inevitable Romney.

This was media hype and little else. He was "winning" in Republican states where conservative ideology, anti-intellectualism and religious fervor play well. And major polls from Pew, CBS/*New York Times*, Fox and CNN showed the same things: Obama held larger leads over Santorum than over

Romney; and Republicans said Romney was more electable than Rick in the fall.

Here's an excerpt from the President's Day column.

Yes, polls change, as we have seen. But some things do not change.

For example, everybody knows that Santorum doesn't like gays in relationships and doesn't like gays in the military.

But he also doesn't like women in the workplace, doesn't like women in combat, doesn't like women (or men) using contraceptives.

He says that contraception is "harmful to women" and society and that "radical feminism" ruined society by encouraging women to work outside the home, which is one reason an Inky *reviewer of his 2005 book,* It Takes a Family, *called Rick "one of the finest minds of the 13th Century."*

This is an asset in many GOP primaries.

The problem is that women vote in national elections. They vote more than men. They've done so in every presidential race, by proportion since 1980 and by raw numbers since 1964...

Santorum's beliefs energize women's fundraising and turnout.

As to his personal traits, think preachy arrogance and doctrinaire judgmentalism.

Over the weekend, he slammed government-supported public education as "anachronistic" (he home schools his kids), and said that President Obama's agenda is based on "some phony theology...not a theology based on the Bible."

But he perhaps said it best in a recent Fox interview: "He believes he's the smartest guy in the room and he should tell people what to believe and how to run their lives."

He was talking about Obama. But his words are a perfect self-assessment.

So enjoy President's Day. I doubt it'll ever be associated with Rick Santorum.

—Philadelphia Daily News, *February 20, 2012*

He exited the race two weeks before the Pennsylvania primary to avoid the embarrassment of losing in his home state.

Don't get me wrong. I love having Santorum around. I hope he rises again. As a Pennsylvania political journalist, I need Santorums and Rendells, Arlens, Fumos, Perzels, Preates, et al.

They were reasons to come to work.

Rick Santorum quits his quest for president in April 2012. *John Whitehead*/Patriot-News.

All journalists need characters, firebrands, wiseacres, risk takers; pols that rise and fall, that are unsteady, unpredictable. Pennsylvania's current top crop—Corbett, Casey, Toomey—are not these things. They don't aspire to these things. There's little evidence they'll ever be these things.

It makes me wonder if maybe the state's political landscape is shifting.

Maybe after all the scandals, the pay raise fiasco and so many pols defeated at the polls or packed off to prison, maybe the state is settling into a new mode.

Maybe Pennsylvania is on the verge of reforming. You know, campaign finance limits, smaller legislature, fewer perks for lawmakers, merit selection of judges, voting reforms, term limits, courts that don't enable unconstitutional pay raises, redistricting reforms, initiative and referendum, recall elections, penalties for not meeting state budget deadlines, ending lawmakers' automatic pay raises and so on.

Maybe state voters will shed their apathy. Maybe state pols will cut back their partisanship and parochialism.

The past twenty-five years haven't seen much progress in these areas. Maybe the next twenty-five years will. Or not.

H.L. Mencken once said, "I believe that all government is evil, and that trying to improve it is largely a waste of time."

I'm not quite there yet. But given the state's past political inclinations and resistance to change, I'm wary. I have my doubts. And I feel safe concluding with the phrase I've often used to close columns bemoaning one shortcoming or another: Pennsylvania, the Land of Low Expectations.

ABOUT THE AUTHOR

Photo by Peter Durantine.

John M. Baer has covered Pennsylvania politics for the Philadelphia *Daily News* since 1987. He is a graduate of Mount St. Mary's University in Maryland; holds a master's degree from Temple University; was a Congressional Fellow under the auspices of the American Political Science Association in Washington, D.C.; and a fellow of Loyola University School of Law's inaugural Journalist Law School program in Los Angeles.

Visit us at
www.historypress.net